OMAHA'S
Henry Doorly
ZOO
& AQUARIUM

OMAHA'S
Henry Doorly
ZOO
& AQUARIUM

EILEEN WIRTH

Photos edited by Carol McCabe

THE
History
PRESS

Published by The History Press
Charleston, SC
www.historypress.net

Copyright © 2017 by Eileen M. Wirth
All rights reserved

First published 2017

Manufactured in the United States

ISBN 9781467136556

Library of Congress Control Number: 2017931806

To all the administrators, donors, staff and volunteers who gave Omaha a world-class zoo, especially the former and current directors, Dr. Lee Simmons and Dennis Pate

CONTENTS

ACKNOWLEDGEMENTS

This book could not have been written without the help of many people, including Beth Black, owner of the Bookworm, Omaha's great independent bookstore, who suggested the idea. We local authors deeply appreciate Beth's support for us.

I am particularly grateful to Dr. Lee Simmons for spending hours sharing his wonderful stories of how major zoo exhibits were created. It would have been impossible to compile this account without his gracious willingness to describe his many years as zoo director.

Many thanks also to Executive Director Dennis Pate for recounting the recent history of the zoo and giving readers a glimpse of its future. He succeeded a legend and has taken the zoo to the next level of excellence—an extremely difficult thing to do. Omaha is so fortunate to have attracted both of these extraordinary leaders.

Other zoo staff members who were very helpful include Jacob Houser, Allison Hecker, Andrea Hennings, Dr. Douglas Armstrong, Dawn Ream, Troy Solberg and Tina Cherica. In addition, the entire guest services staff were terrific.

My dear friend and fabulous photo editor Carol McCabe took over the visual part of this book. I could not have completed it without her involvement. Thanks also to my former student Mary Plambeck Cook for shooting many photos in limited time on short notice.

Martha Grenzeback and Lynn Sullivan of the Omaha Public Library's history department were cheerful sources of material from the zoo's early

years. Emily Getzschman of the marketing department provided a great photo based on information about zoo membership drives from longtime PR friend Rosalee Roberts. Thanks also to the Omaha Public Library Foundation and its director, Wendy Townley, for obtaining funding for the historic online database of the *Omaha World-Herald*, which was invaluable in researching this book. My friend Phyllis Choat gave me interesting information about her family's farm, which is now part of the zoo.

My research assistant Dominic Dongilli, a Creighton University alum who works at the zoo, checked and formatted the bibliography and endnotes.

Finally, thanks to my copyeditor Abigail Fleming and Ben Gibson of The History Press. Ben has been a wise and patient colleague who guided this project from the beginning. My apologies if I have overlooked someone important. Any errors or omissions in this book are strictly mine.

INTRODUCTION

We want to use the Zoo to compel people to care about
the plight animals in the wild.
—Dennis Pate, executive director of the Henry Doorly Zoo and Aquarium[1]

Our goal with many of the Henry Doorly Zoo and Aquarium exhibits is to
immerse people in ecosystems that they would never otherwise experience.
—Dr. Lee Simmons, director of the Omaha Zoo Foundation
and former longtime zoo executive director[2]

When Omaha was young, its leaders envisioned a grand series of parks linked by boulevards to beautify the booming community. To accomplish this, the city approved a park bond issue in 1892. As part of the plan, it established Riverview Park in southeast Omaha and decided that it would house a small zoo.

That zoo limped along as little more than a menagerie until the 1950s, when Omaha leaders noted that not only did major midwestern cities like Chicago and St. Louis feature outstanding zoos but also that even Lincoln, Nebraska, was planning a children's zoo.[3] The Omaha Zoological Society slowly raised funds for a children's zoo adjacent to Riverview Park Zoo until August 1963, when Margaret Hitchcock (Mrs. Henry) Doorly donated $750,000 to create a full-fledged zoo.

"It is my hope that…a zoo can be established which will ultimately constitute a great asset to the City of Omaha and its community life," wrote

In this handwritten letter, Margaret (Mrs. Henry) Doorly announced her $750,000 donation to transform the Riverview Park Zoo into a real zoo. *Courtesy of Omaha's Henry Doorly Zoo and Aquarium.*

Mrs. Doorly. "I visualize that ultimately the zoo will be comparable to some of the zoos which have been established in other cities of comparable or even larger size." Mrs. Doorly, a lifelong animal lover and widow of *Omaha World-Herald* publisher Henry Doorly, also requested that the zoo be renamed in his honor.[4]

This book is the first-ever history of Omaha's Henry Doorly Zoo and Aquarium. It describes the zoo's evolution from a handful of cages and pens in Riverview Park to today's world-class attraction in which visitors immerse themselves in ecosystems that they would never otherwise experience. In a couple hours they can travel through rainforests, deserts, oceans, swamps at night and regions like the African grasslands, where animals live comfortably in re-created natural habitats. This zoo isn't just a place to *see*—it's a place to *be*!

The history of Omaha's Henry Doorly Zoo and Aquarium also is the story of the city's love for the zoo that brilliant executive directors and generous donors created. Collectively, they took Mrs. Doorly's dream and created both a national wonder and one of Omaha's greatest civic assets. For years, it has been Nebraska's top tourist attraction.

An Overview of the Henry Zoo and Aquarium

The 130-acre Henry Doorly Zoo and Aquarium sits atop the hills overlooking the Missouri River just off Interstate 80. While a few relics of the Riverview Zoo, such as the lagoon and the old caretaker's house, remain, this cutting-edge facility constantly evolves.

Construction fences and bulldozers speak to the major expansion of the zoo under a ten-year master plan adopted in 2010. The zoo also acquired the grounds of the old Rosenblatt Stadium for added parking but preserved artifacts of the stadium in an exhibit of its infield, where home plate remains in its historic location. Another major exhibit, the Children's Adventure Trails, is scheduled to open in 2017.

And the public never even sees some of the zoo's most important work—its cutting-edge research in animal and plant conservation and reproduction. It is as important to scientists seeking to preserve endangered plants and animals as it is to Omaha's young families.

Walking briskly up and down hills through the grounds without stopping to savor any of the exhibits takes about three strenuous hours. However, visitors who want to see more in a typical four-hour visit can ride the Omaha Zoo Railroad, getting on and off at stations, or take Skyfari, a ski lift–style ride, for an aerial view of the grounds.

Here are some of the zoo's premier attractions whose development will be described in detail throughout the book:

- The **Desert Dome**, a massive acrylic architectural dome, houses both the nation's largest indoor desert and the subterranean **Kingdoms of the Night**, which features animals that are active at night and a creepy but unforgettable Louisiana bayou.
- The **Lied Jungle** is one of the world's largest indoor rainforest exhibits.
- The **Suzanne and Walter Scott Kingdom of the Seas Aquarium** features 1.3 million gallons of salt water, penguins and an acrylic tunnel with sharks overhead.
- The **Suzanne and Walter Scott African Grasslands Exhibit** is home to giraffes, elephants, lions, rhinos, cheetahs, impalas, zebras and more African species in a large grassy area modeled on East Africa's veldt.
- The **Owen Sea Lion Plaza** was built in a converted 1916 Riverview Park swimming pool.

- **EXPEDITION MADAGASCAR** features rare animals from this Indian Ocean island nation where the zoo runs an important biodiversity conservation program.
- The **LEE SIMMONS FREE FLIGHT AVIARY** is a large netted outdoor area where bird lovers can search for birds in trees and foliage.
- At the **HUBBARD GORILLA VALLEY** and the adjacent **HUBBARD ORANGUTAN FOREST**, the primates inside the floor-to-ceiling glass enclosures and in twenty-one thousand square feet of outside exhibits can enjoy watching the visiting public watch them.
- In **DURHAM'S BEAR CANYON**, polar and grizzly bears live in grotto-style exhibits common in earlier eras.

There's much more, of course: two popular children's petting areas; an IMAX theater showing nature movies; a cat enclosure; a carousel; exhibits of butterflies, insects, reptiles and prairie dogs; a koi pond; and so forth. There also are research and educational facilities, to say nothing of refreshment stands and other amenities to enhance the guest experience. With an annual budget of about $35 million and more than eight hundred employees, the zoo has an estimated local economic impact of more than $226 million.[5]

PLAN OF THE BOOK

This book moves chronologically through the zoo's history from its founding to its newest exhibits. After the first two chapters on Riverview Zoo's history and the transition to the Henry Doorly Zoo, the book describes the development and the creation of exhibits decade by decade. It also details the history of the zoo's important contributions to animal and plant research and conservation and closes with a description of the master plan that should keep Omaha's Henry Doorly Zoo and Aquarium a world leader into the future. The appendices contain the chronology of significant events and other historical information, such as the numerous awards that the zoo has won.

BIRTH OF A ZOO

In 1898, North Omaha was in the national spotlight, as some 2.6 million visitors, including President William McKinley, toured the Trans-Mississippi and International Exposition in today's Kountze Park area. It featured pavilions glowing with twenty thousand electric lights on a Venetian lagoon, sculptures and paintings, displays of industrial products and other wonders of the era.[6]

On the southeast edge of Omaha, a far humbler attraction drew an unrecorded number of guests. The four-year-old Riverview Park Zoo at Ninth and Frederick Streets showed off *its* prize exhibit—two buffalo loaned by Colonel William F. Cody, better known as Buffalo Bill—along with 120 other animals.[7]

Who could have imagined that this primitive display of a few humble pens and cages showcasing Great Plains animals would eventually give way to one of the world's best zoos?

BIRTH OF A ZOO

In 1892, Omaha approved a bond issue to build parks in the undeveloped areas on its edges while land was still available. The bond issue's timing was fortunate, because a year later, the Crash of 1893 plunged the nation into a devastating depression that nearly paralyzed Omaha's economy. The

crash ended a decade of prosperity when Omaha's population grew about 40 percent. After the crash, a local historian wrote, "[F]or many people, soup kitchens and charity houses seemed the only flourishing establishments. Construction stopped; over 5,000 homes stood empty. There was no money available."[8] Even Omaha's iconic Union Pacific Railroad went bankrupt.

However, thanks to the bond issue, the park board still had money to create new parks. In 1894, despite the depression, it purchased sixty-five acres near Ninth and Frederick Streets to build Riverview Park, whose attractions would include a small zoo.[9]

The location caused some unhappiness. The city had to use eminent domain to purchase the land because property owners felt they were being underpaid. One parcel of the original land (site of today's aviary and lagoon) was a farm owned by Michael Sautter, a German immigrant who came to Douglas County in the 1850s. Some of Sautter's descendants still boast of their connection to the zoo.[10] Later, the zoo acquired additional land on the east side of the zoo at Second and Grover Streets from Mable Hrabik, whose family had owned the land for decades. She served as unofficial night watchman of the zoo before she died at age ninety-six.[11]

Omaha hired H.W.S. Cleveland, a noted Minneapolis landscape architect, to advise on planning the park. While he approved of the location, he wasn't sure how to design a tranquil rural park in sight of the Missouri River, which he described as a "turbid and untamable stream." Residents also complained that the site was too far from their homes and so hilly that "the land could not support a table on four legs."[12]

When Cleveland's health failed, park superintendent W.R. Adams designed a park featuring a lagoon and winding drives. In 1896, the park board purchased the zoo's first animals, including a moose ($150), a grizzly bear ($25) and "moving fish" ($1).[13] By 1899, Riverview Park covered more than one hundred acres, with increasing portions of the acreage devoted to the zoo. Other improvements included a replica of a Greek temple that was moved from the site of the Trans-Mississippi Exposition. It became Riverview's pavilion, and free concerts were held there. These became especially popular after the electric streetcar line was extended to Riverview's entrance on South Tenth Street.[14]

By 1900, Riverview had grown to 108.3 acres with the park board's purchase of additional land.[15] By 1901, the zoo featured native stone quarters for bears as well as pastures for deer, elk and buffalo. Stone cages set into the hillside displayed mountain lions, foxes, coyotes and badgers. By 1917, the zoo's collection also included monkeys, bobcats, wolves,

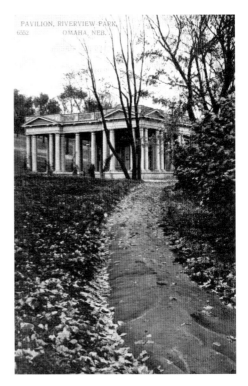

These photos show the lagoon and a pavilion at old Riverview Park before it became the Henry Doorly Zoo. *Courtesy of the Omaha Public Library.*

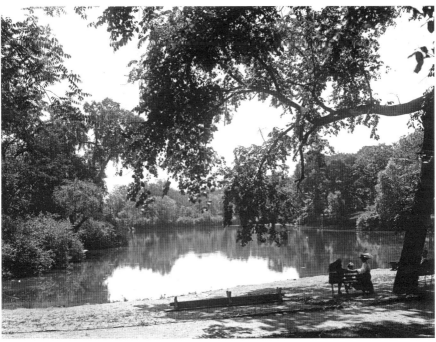

opossums, alligators, Mexican ducks, pheasants and even a freak five-legged cow.[16] Omaha's German population contributed a monument to the poet Friedrich Schiller in 1905, but paint was sloshed over it in 1917 as hostility to Germany swept across Nebraska during World War I. After the war, the statue was restored.[17]

While the zoo was anything but spectacular, it gained occasional notoriety for incidents like the goring death of its caretaker in 1912. Nels Anderson, who served as caretaker of Riverview Park from 1897 to 1912, lived on the grounds with his family in the caretaker's house, which remains on the zoo grounds. He fed the animals as part of his job. Because Anderson knew all the animals, and vice versa, they allowed him to approach them, especially at feeding time. However, the biggest and oldest of the buffalo, Monarch II, had gone blind. One morning, when Anderson went to feed the buffalo in their fenced yard, Monarch II apparently did not recognize him. After Anderson failed to return home for breakfast, his wife discovered that Monarch II had gored and crushed her husband.[18] The caretaker's home has been moved several times but is still in use at the zoo. It now sits near the Desert Dome.[19]

Riverview Park suffered an even greater tragedy at a picnic in 1919 when four children from St. Agnes, St. Francis and St. Mary Parishes in South

The old Riverview Park Caretaker's House remains on the zoo's grounds near the Desert Dome. *Photo by Mary Plambeck Cook.*

During the 1930s, the Works Progress Administration built numerous animal cages like these at Riverview Park Zoo. *Courtesy of Omaha's Henry Doorly Zoo and Aquarium.*

Omaha drowned while boating on the lagoon. The girls were in one boat and the boys in another when the girls' boat sprang a leak. Seeing that the girls' boat was sinking, the boys rowed over to help. The frightened children overturned both boats and screamed for help. Boys who had been playing baseball heard the cries and swam out to try to rescue their friends. They pulled nine children to safety, but four drowned.[20]

Other incidents had happier endings. In December 1926, the zoo acquired its first two reindeer, but a year later, the caretaker reported them missing. Omaha children pleaded with their parents, teachers and even the police to find the reindeer and return them to Santa Claus before Christmas. Fortunately, members of the news media reported receiving a telegram from Santa Claus that the deer had appeared at the North Pole and were ready for their annual trip, including a stop in Omaha. Then, on December 26, Santa appeared with city and park officials and returned the reindeer to Riverview.[21]

The zoo received occasional donations from benefactors such as Dr. Gould Dietz, a globetrotting Omaha businessman and veterinarian. In 1928, he contributed money to construct lion cages. Earlier, he had presented a baby

deer to First Lady Grace Coolidge.[22] In 1937 and 1938, the federal Works Progress Administration built a monkey house and additional cat cages. The monkey house was later remodeled to serve as a diet kitchen.[23]

During the Great Depression and World War II, the zoo received little attention in the local media. Throughout the 1930s and early '40s, the *Omaha World-Herald* usually carried fewer than fifteen articles a year on the zoo, mostly mundane stories about animals being born or dying. Some stories reflected the bad economy or wartime austerity. In 1939, a city official suggested giving away the buffalo because they were consuming more food than the city could afford.[24] Despite this, the buffalo remained until 1945, when Omaha finally gave away the aging animals with no obvious objections from anyone.[25]

There was a far different reaction to the auction of two of the zoo's three lions during World War II, when a zoo official lamented the necessity of the loss.[26] Even after the war, Floyd Hinton, who was zoo director from 1953 to 1963, sometimes had to scrounge for food for the animals from South Omaha's packinghouses and supermarkets.[27]

The Transformation Begins

However, during the prosperous years of the 1950s, some prominent Omahans started dreaming of a better zoo. In 1952, the Omaha Zoological Society was founded to promote and maintain a "bigger and better" zoo. The society received all concession revenues to fund zoo expansion and used the revenue to build new cages, a concession stand and winter quarters and to purchase additional animals.[28] In 1953, the *Omaha World-Herald* reported that the Omaha Zoological Society had started a campaign to "make the Omaha zoo a real zoo." The paper said that "in drought, depression and rationing days during war-time [the zoo was] pretty hardly depleted if not actually decimated." The zoo had only fourteen intact cages, two built in 1917. In comparison, the St. Louis Zoo had about two thousand animals.[29]

In 1955, the zoological society hired Robert Everly of Glencoe, Illinois, to help it chart its course. When he toured the zoo, he said that the Riverview Zoo was "ideally located," with the hills, ravines and trees giving it a great advantage topographically over the Chicago's Brookfield Zoo, which had been built on a former swamp.

Everly thought Omaha's zoo should be primarily educational, but he also cited its commercial potential. "I see no reason why an Omaha zoo could not attract people from all of Nebraska and Iowa," he said.[30] A few months later, Everly proposed a master plan for a "complete zoo" that would provide facilities for various kinds of animals, including elephants, rhinoceroses, tigers, reptiles and others.[31] The plan was similar to those he had suggested to zoos in other cities.[32]

Gradually, the zoo acquired more interesting animals, including a llama, an emu, an elephant and more. In 1958, a group studying the park's needs proposed spending $1.81 million to relocate the zoo to Riverview Park's north side and significantly upgrade the facility as part of an overall urban renewal plan. However, voters later rejected the proposal.[33]

Zoo advocates did not give up. In 1963, the zoological society launched a drive to raise $350,000 for the children's zoo adjacent to the existing zoo.[34] Then, on August 29, 1963, the future of the zoo was changed forever, as Margaret Hitchcock (Mrs. Henry) Doorly, widow of the publisher of the *Omaha World-Herald*, gave the zoological society $750,000 to create a major new zoo named after her husband in place of the existing zoo, which she called "pathetic."[35]

THE DOORLY GIFT

Mrs. Doorly was the daughter of U.S. senator Gilbert Hitchcock, who founded the *Omaha World-Herald*. A great animal lover, she not only raised dogs and horses but also rode a bear and camels and let a boa constrictor wrap itself around her arm at the Hagenbeck Wild Animal Show during the Trans-Mississippi Exposition. Later, she rode elephants at zoos in London and Colorado Springs and a tortoise at the Bronx Zoo. When she was a child, she would have taken a lion cub home if her father had permitted it.

She also hated confining animals in cages.[36]

In her hand-written letter to the Omaha Zoological Society, Mrs. Doorly stipulated that the new zoo be named in honor of her husband as a condition of the gift. She also said that she hoped the zoo would be located at Riverview Park and the animals "not be kept in confining cages" but controlled by moats and other means of allowing as much freedom as possible.

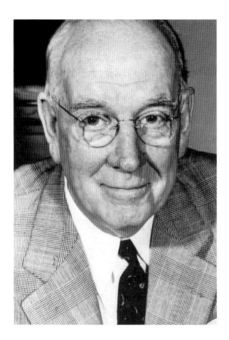 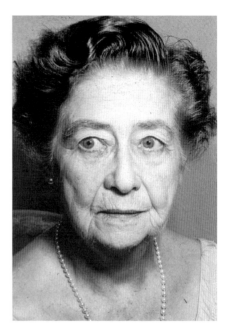

Left: Henry Doorly was the longtime publisher of the *Omaha World-Herald* for whom the zoo was named at his wife's request. *Courtesy of Omaha's Henry Doorly Zoo and Aquarium.*

Right: Margaret Hitchcock Doorly envisioned a zoo that gave animals as much freedom as possible. *Courtesy of Omaha's Henry Doorly Zoo and Aquarium.*

"I visualize that ultimately the zoo will be comparable to some of the zoos which have been established in other cities of comparable or even larger size and be a truly great civic asset to Omaha," she concluded.[37]

Mrs. Doorly died in May 1964, but several months later, her daughter Kay D. Clark reminded zoological society president Larry Shoemaker of her mother's concern for an open zoo. "One of Mother's reasons for giving a zoo to the city was to assure a naturalness of surroundings. Not only by moats but by large winding enclosure. Somehow I hope this can all be done, to get away from the feeling of entrapment." Mrs. Clark hoped for a zoo where the animals were happy and visitors could enjoy having a picnic.[38]

The long years of a zoo that merely limped along had ended.

2

THE PIVOTAL DECADE

The 1960s

With Mrs. Doorly's game-changing gift, Omaha went from struggling to create a children's zoo to planning a significant regional zoo just as the zoo world was changing. Old ideas about displaying animals in cages were giving way to more natural settings, and Omaha would be one of the first zoos to start almost from scratch, a huge advantage in creating the zoo of the future. Parks activist Rachel Gallagher called Mrs. Doorly's gift "the key that unlocks the city."[39]

Mrs. Doorly's gift was enhanced by a donation of $250,000 from Peter Kiewit, president of Peter Kiewit Sons' Incorporated, who had purchased the *Omaha World-Herald* from the Doorly family in 1962. That brought the total to begin work creating the new zoo to $1 million.[40] The gift also began Kiewit's own transformative involvement with the birth of the new zoo.

The Omaha Zoological Society hired Dr. Warren Thomas, director of the Oklahoma City Zoo, to help with planning. He began educating Omaha about what a great zoo could do for the city, telling city leaders that in 1962, more people attended zoos than all forms of organized athletics. In addition, zoos could be a sanctuary for animals in danger of extinction, and they offered educational benefits.[41] Two years later, Thomas was named director of the Henry Doorly Zoo.[42]

However, the zoo's location in Riverview Park was threatened by the construction of Interstate 80, which was originally scheduled to run through the park. In June 1964, the Nebraska Highway Advisory Commission agreed to move a proposed route far enough north to save most of the

park.[43] The decision not only saved the zoo's most likely site but also contributed to its future success. "The fact that we are a block off one of the country's major east–west arteries has a lot to do with the number of visitors we attract," said Dr. Lee Simmons, former zoo executive director and chairman of the Omaha Zoo Foundation.[44]

Some Omaha leaders urged the zoological society to consider other locations, such as Hanscom Park or Dodge Park, but ultimately the Riverview site was chosen.[45] Among those endorsing it was Marlin Perkins, star of the popular *Wild Kingdom* television show sponsored by Mutual of Omaha. Perkins argued that Riverview "is located about as well as it could be in relation to the city."[46] In 1965, the zoological society was reorganized as a nonprofit organization to plan, build and maintain the greatly expanded zoo after it negotiated financial and operating arrangements with the city council.[47]

By the end of the pivotal year 1965, the zoo had hired Dr. Thomas as zoo director, dedicated the first phase of zoo construction to Henry Doorly and begun major construction projects, including the bear grotto and gorilla and orangutan building. Just as the year was ending, Aksarben donated $165,000 for the children's portion of the zoo, the Nature Kingdom.[48]

Zoo Leadership

When Thomas joined the Henry Doorly Zoo, he was one of the nation's rising zoo directors. A native of Columbus, Ohio, he received his veterinary medicine degree at Ohio State University in 1959 and later became director the Oklahoma City Zoo. In Oklahoma City, he met a local kid, Lee Simmons, who had been "hanging out" at the zoo for years hoping to become a herpetologist specializing in reptiles such as snakes. However, Simmons had learned that to become a zoo director, he should switch to veterinary medicine; only a dozen zoos at the time had staff veterinarians.[49]

After Simmons received his DVM degree from Oklahoma State University in 1963, he joined the Columbus Zoo as its curator, later becoming its veterinarian and assistant director. Simmons was not thrilled with his job at the Columbus Zoo because of its politics. When he connected with Thomas at a conference in Washington, D.C., Simmons agreed to explore his offer to become the Henry Doorly Zoo's veterinarian.

"This was a new zoo that was building," Simmons said. "I was impressed because there seemed to be a lot of money. It was a lot closer to family, and Warren had a reputation in the zoo world as someone who wouldn't be in one place for long. There was a good hoof stock collection and the beginnings of a cat collection in addition to the gorillas and orangutans. I could see the potential."[50]

Simmons became the staff veterinarian on December 1, 1966, and by June 1967, he had become assistant director. When Thomas resigned to become director of the zoo in Brownsville, Texas, in 1970, Simmons became acting director. By the end of the year, he had been named director, a post he held until 2009.

"When Marie [his wife] and I came to town, the zoo had ten employees and the budget was $100,000 from the city. When I became director [in 1970] we had fourteen employees and a budget of $350,000."[51] When he retired as director in 2009, the zoo had a multimillion-dollar budget and was ranked as one of the world's best zoos.

CREATING A ZOO FOR A NEW ERA

Although Omaha dreamed of a greatly expanded zoo with a larger and more diverse collection of animals, there was "no grand design to create today's zoo," Simmons said. "We still had a lot of bars. They were holdovers from when zoos had buildings and enclosures built by the WPA [Depression-era job agency]. The WPA built a lot of zoos in the 1930s."[52] Omaha's bear grotto, built from stones from the Platte River, was a relic of that era.

It took years, but eventually an overriding vision emerged—one of creating exhibits that would allow visitors to immerse themselves in environments that they would likely never experience and of seeing animals in close to their natural habitats. This vision was consistent with Mrs. Doorly's hope for her zoo.

Her desire for a more open zoo was consistent with advances in veterinary medicine and concerns about better ventilation for animals. Omaha's late start in creating its zoo gave it an advantage over older zoos that wished to move in new directions but had to work around old buildings, some of which were landmarks that could not easily be demolished. Zoos in Chicago, St. Louis and the Bronx were among those struggling with such problems. In contrast, Riverview Park had lots of land, and "nothing was

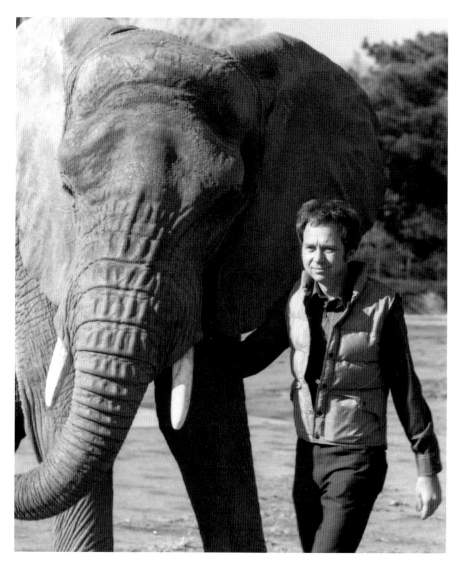

Dr. Lee Simmons with Malika, one of the Henry Doorly Zoo's elephants that lived on Eugene C. Eppley Pachyderm Hill. *Courtesy of Dr. Lee Simmons.*

sacrosanct," excepting the caretaker's house built in 1900. It remains on today's zoo grounds adjacent to the Desert Dome after being moved to make way for the dome.[53]

Simmons began networking with civic leaders whose backing was crucial. He got acquainted with E. John Brandeis (of the Brandeis Store family), who refused to donate to the zoo because he had disliked Henry

Doorly. Instead, Brandeis contributed the Elgin Gates collection of mounted animal heads and horns, which were displayed in Riverview's old picnic pavilion. Gates was a noted big-game hunter.[54] Simmons's most crucial meeting occurred in 1968 when he was still assistant director and Peter Kiewit drove up to inspect some construction work.

"One morning in 1968 at about 7:00 a.m. I was checking employees in as they came to work," Simmons recalled. "Pete Kiewit drove up and introduced himself, and I introduced myself. He asked if I had time to drive around. We drove around, and as we were by the children's zoo, he asked me what we really needed, not what we wanted."

Simmons told Kiewit that the zoo needed an elephant house instead of corrals made out of Union Pacific salvaged bridge planks. Because the elephants would eat through the planks, the corrals had to be repaired daily. Simmons feared that the zoo would eventually have to dispose of the elephants because they couldn't be effectively sheltered.

Two hours after Kiewit left the zoo, Thomas summoned Simmons, asking, "What the hell did you do?" Architect Leo A. Daly, one of Kiewit's closest business associates, had called and informed Thomas that "we were building an elephant house and you [Simmons] know all about it."

Simmons discovered that following their chance meeting, Kiewit had joined Daly and a few other business leaders for coffee. They had discussed the zoo's need for an elephant house and determined who might pay for it. "That's how we got the Eugene C. Eppley Pachyderm Hill building."[55] This set the pattern of development to come: Simmons identified a need or project, and business leaders found a way to fund it. Today, most zoo buildings are named for their donors—a who's who of Omaha corporations, foundations and philanthropists.

The zoo's strongest supporters also included Union Pacific Railroad, which built and largely financed the Omaha Zoo Railroad. The attraction opened in 1968 with the driving of golden spikes to parallel the golden spike that completed the original UP. The two-and-a-half-mile railroad through the zoo featured a small steam locomotive pulling several passenger cars.[56] The track was laid by UP crews using rail from UP's Encampment branch in Wyoming. The steam locomotive was painted and decorated to resemble Union Pacific's No. 119 locomotive, which had been used at the driving of the real golden spike in 1869. For years, the railroad serviced the zoo's equipment at its Omaha Shops, and it donated much of the machinery to the zoo's Union Pacific Engine House when the shops closed in the 1980s.[57] Simmons credited Union Pacific

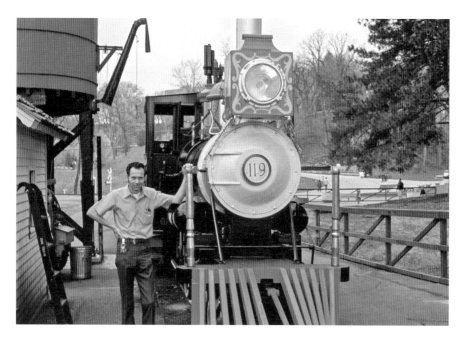

Dr. Lee Simmons with the Omaha Zoo Railroad's 119 Steam Locomotive. Union Pacific Railroad helped maintain the zoo railroad and its equipment. *Courtesy of Dr. Lee Simmons.*

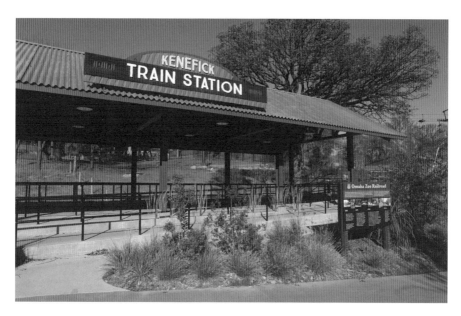

Today's Kenefick Station in the African Grasslands Exhibit is named for John C. Kenefick, former president of Union Pacific Railroad. *Photo by Mary Plambeck Cook.*

chief engineer Robert N. Brown, a zoo board member, with driving the project ahead.

Simmons described Brown as "an animal guy and a good friend" who would loan the zoo any equipment it needed. He also spent a great deal of time at the zoo, especially when the railroad was being constructed. When John C. Kenefick became president of Union Pacific in 1971, he summoned his top executives to a meeting but could not find Brown because Brown was at the zoo. When Brown returned to UP headquarters, Kenefick asked what he was doing at the zoo. Brown informed him that UP was building a railroad for the zoo. Brown also asked if Kenefick wanted to know exactly what Union Pacific was doing for the zoo or if he just wanted him to keep doing it. Kenefick allowed Brown to continue helping the zoo but told him to keep the railroad "out of trouble."[58] The zoo later named one of its railroad stations for Kenefick.

A PIVOTAL DECADE ENDS

By 1970, the Henry Doorly Zoo had taken strides toward its future excellence. The collection of more than 350 animals represented about 120 species, and plans were in place for a collection of 3,000 animals from 1,200 to 1,400

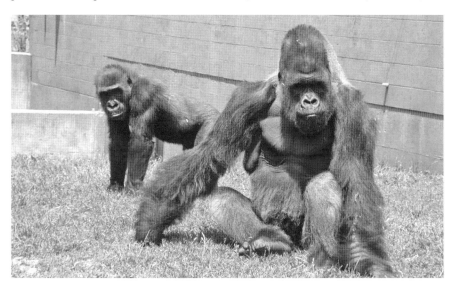

Casey the gorilla was so popular that the *Omaha World-Herald* wrote an obituary for him after his death. *Courtesy of Dr. Lee Simmons.*

species.[59] These animals included Casey the gorilla, who became so popular that the newspaper wrote an obituary about him; polar bears enjoying their new quarters; orangutans; and many more. Public excitement about the zoo kept building. In 1968 alone, attendance rose more than 90,000 over the previous year. By the end of the decade, it stood at more than 330,000. Visitors were coming from throughout the region, and the *World-Herald* carried hundreds of stories a year about the zoo's progress and activities. But even more exciting developments were on the horizon.

SUPPORT YOUR LOCAL CAT HOUSE

The 1970s

During the 1970s, the Henry Doorly Zoo might be compared to a caterpillar transforming itself into the beautiful butterfly of the future:

- The animal collection was growing to include more elephants and giraffes, as well as rare species that drew respect from other zoos. Research into preserving endangered species began.
- The zoo discovered a 1916 swimming pool that it converted into a sea lion pool, and it built the nation's largest cat complex thanks to the help of major donors and Omaha businesses.
- Omahans began joining the zoo in large numbers, and attendance grew significantly. By the end of the decade, the zoo had become the city's most popular institution and the favorite cause of many top businesses and philanthropists.

Meanwhile, colorful mayor Eugene Leahy gave citizens their marching orders: "Support Your Local Cat House."

SIMMONS BECOMES DIRECTOR

After becoming zoo director in 1970, Dr. Lee Simmons began to pursue his imaginative but practical dreams for further developing the zoo. He had

already built strong ties with key leaders of the Omaha Zoological Society Board, such as Union Pacific's Robert Brown and Ed Owen, head of Paxton & Vierling Steel, both of whom played important roles in bringing loveable California sea lions to Omaha.

OWEN SEA LION PLAZA

Two of Simmons's goals for the zoo were a conservation program for endangered species of animals and to exhibit popular zoo animals, including lions, tigers, giraffes, elephants and sea lions. He was well on his way with the cats, giraffes and elephants, but sea lions required a pool. Simmons was unaware that the old Riverview Park had just what he needed as a starting place for a popular new exhibit.

"We had a little seal pool in the Aksarben Nature Kingdom [children's zoo] but I was griping because we didn't have a sea lion pool," Simmons said.[60] Then, a former Riverview Park plumber told Simmons that the zoo still had an old pool that had closed during a polio scare in 1938. Riverview Park officials had buried it in 1944. The plumber took Simmons to the pool's site and showed him a faint yellow line in the grass on its west side. When zoo workers probed the area with steel rods, they located the concrete structure. However, converting the old pool to a sea lion exhibit would be an engineering challenge.

As he often did in such cases, Simmons turned to Brown and Union Pacific for help. Brown, who could loan the zoo construction equipment from the railroad's extensive inventories without asking permission from anyone, provided the heavy digging machinery required to unearth the old pool. But that was just the beginning of the engineering and construction problems that Brown helped solve.

The original design for Riverview Park included a lagoon that had been fed by artesian wells, but over the years, they had quit flowing. The lagoon also had silted in and become "yucky and smelly" in summer heat. Water for the lagoon supposedly came from a Riverview Park spring located on the park's east side. Having enough water was key to converting the old swimming pool into a sea lion pool and giving new life to the lagoon. Once again, Simmons turned to Brown.

"We got UP to dig it [the lagoon] out to eighteen feet deep and create islands from the sludge," Simmons said.[61] Just when the lagoon was ready

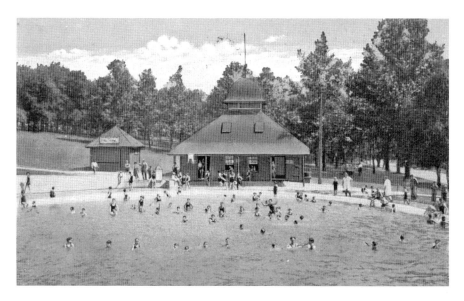

This photo shows swimmers in the old Riverview Park Pool, which was transformed into a home for sea lions. *Courtesy of the Douglas County Historical Society.*

The zoo lagoon, a feature of the grounds since the beginning of Riverview Park, runs through today's African Grasslands Exhibit. *Photo by Mary Plambeck Cook.*

to be refilled, two men from the city showed up to say that the source of the lagoon's water actually was a regular city water main, not some mysterious spring. The water officials shut off a valve and put a meter on the main. Then they offered to sell more water to the zoo, but the zoo couldn't afford the cost.

Instead, Brown and UP loaned the zoo a long shaft turbine from a Wyoming well and used it and a tractor to suck the muck out of the 1908 well. This well supplied six hundred gallons per minute for many years for the lagoon and sea lions. Ultimately, the zoo drilled a new well on a hillside, and it provided water for both the lagoon and the sea lion pool. Simmons remains grateful to Union Pacific and Brown. "Every time we had a problem, I went to UP, and they found the equipment and did the engineering," Simmons said.[62] Simmons also needed a major donor to help fund the $250,000 cost of converting the pool for sea lions. Once again, the stars aligned.

Just as Simmons was envisioning the project, Owen, an enthusiastic zoo board member, told Simmons he was going to London and wanted to see the London Zoo while he was there. Simmons called the London Zoo, and it sent a guide who headed its marine mammals department. The guide "talked sea lions with Ed all day." Owen came back excited to sponsor the conversion of the pool that today bears his name. The 333-gallon, eighty-five by one-hundred-foot pool originally housed six sea lions from Santa Barbara that entertained guests during the grand opening.[63] The project also included a new concessions building, public restrooms and a gazebo. The following year, Owen Swan Valley opened.

Today, the California sea lions are still delighting zoo goers as they cavort in their pool year-round, comfortable in the sixty-five-degree water. The water level is lowered to create a beach when a sea lion pup is about to be born because the newborn pups cannot swim.[64] The zoo's ten-year master plan envisions replacing the current pool.

FUNDING ZOO GROWTH

Thanks to donations from the private sector, the zoo's growth had far outstripped the City of Omaha's ability to support its operating costs. Rising attendance income expanded the budget beyond the $100,000 a year that the city was contributing, but it wasn't enough. The answer was an expanded partnership with citizens and the private sector.

To generate additional income, the zoo created an endowment with the assistance of Willis Strauss, head of Northern Natural Gas, then one of Omaha's top companies. When Peter Kiewit died in 1979, he left the zoo $1 million for its endowment. Ultimately, the zoo's board also created the Omaha Zoo Foundation to raise private capital and endowment funds that a city department could never have attracted.

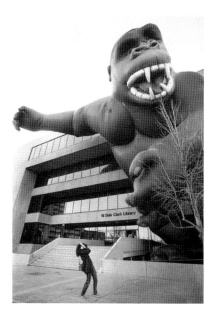

Meanwhile, the zoo began to rely more heavily on the annual membership drives that began in 1971 for construction funds. For the first two years, the zoo merely advertised the membership drive in the *Omaha World-Herald's Magazine of the Midlands* for two Sundays. The first drive drew eight hundred members and netted $8,000. The results were gratifying. The potential was obvious, especially to Omaha leaders, who had developed

Zoo officials promoted membership drives with imaginative slogans like "Thrill a Gorilla." This photo shows a blowup of King Kong hanging from the W. Dale Clark Library in connection with the drive. *Courtesy of the Omaha Public Library.*

a local model that the zoo could copy: the Aksarben workplace-based membership drive.

Aksarben (Nebraska spelled backward) is an Omaha civic organization formed in the 1890s to promote entertainment and economic development. For years, it sponsored horse racing, a rodeo, concerts and events such as the Aksarben Coronation, a sort of local debutante ball. Members of the board of governors were the most powerful business leaders in the city, and collectively, they often decided what civic endeavors to back, including the zoo.

Zoo board member and former president Ben Morris, an official of Northwestern Bell Telephone Company, created the workplace-based drive modeled on the Aksarben drive that the zoo still uses. If thousands of Omahans would join Aksarben to attend a few concerts and a rodeo, why wouldn't they buy a zoo membership? For the relatively modest cost of a family membership, all family members get unlimited access to the zoo, a deal that people with children especially enjoy. As a result, Omaha has the

largest per capita zoo membership in the nation, with more than eighty-five thousand individual and family memberships sold annually.[65]

In the 1970s, the zoo also created Zoofari, its biennial signature fundraising event. Zoofari, a high-end auction, generally raises at least $2 million. For years, guests bid on the opportunity to feed popular individual animals for a two-year period. More recently, guests bid on exclusive experiences at the zoo, with keepers giving private tours. Gail Koch, Mrs. Henry Doorly's granddaughter, chaired the first Zoofari.

While the zoo still maintains multiyear contracts with the city, Omaha's share of the zoo's operations budget has fallen to a very small percentage.[66]

Support Your Local Cat House

By the mid-1970s, improving the zoo's facilities for lions, tigers, leopards and other big cats had become Simmons's top exhibit priority. Before creation of the new Cat Complex, the zoo housed its growing cat collection in antiquated cages dating to the 1920s and '30s. In the forty years since the WPA had built such cages, zoos had begun to display big cats in more natural settings that allowed them to move more freely. This was the direction in which Simmons wanted to move, and he began planning the nation's largest cat complex. Public enthusiasm for his plan fueled three successful membership drives especially after the popular Mayor Leahy spontaneously provided the zoo with its most memorable drive slogan: "Support Your Local Cat House."[67]

The slogan emerged from a press conference at the Omaha Press Club where Simmons had asked the mayor to issue a proclamation endorsing the upcoming membership drive. The television photographers had to leave the press conference to cover a major fire, but they promised to return. Meanwhile Leahy and Simmons adjourned to the club's bar to wait out the delay. Feeling relaxed by the time the media returned, the mayor told reporters that he had a message for citizens: "I will just tell everyone to 'support your local cat house.'"[68]

A Mutual of Omaha Junior Achievement group picked up on the quip and designed T-shirts featuring it. These were an instant hit during the drive and for years after. The zoo sold the T-shirts in its gift stores for fifteen years, and a nightclub in Kansas even adopted them as an employee uniform.[69] Funds from the membership drives helped raise the $2.5 million required to open the nation's largest cat complex in 1977—the first Henry Doorly

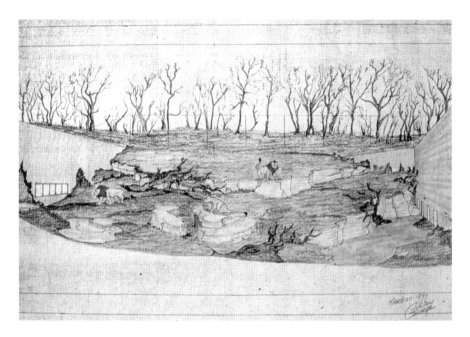

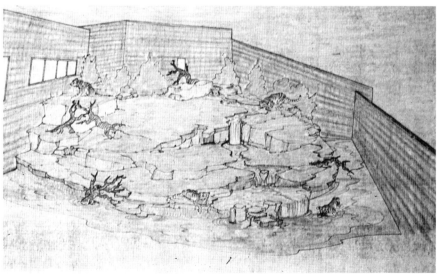

These architect's drawings show plans for the Cat Complex, the first Henry Doorly Zoo exhibit to win national attention. *Courtesy of Dr. Lee Simmons.*

An architect's schematic of the Cat Complex. *Courtesy of Dr. Lee Simmons.*

Zoo exhibit to gain national attention. The current master plan calls for the complex to be replaced, with the cats moving to much larger habitats.

Although Henry Doorly's Cat Complex technically can hold up to one hundred large cats, it has never housed more than eighty-five. These have included three subspecies of tigers, lions, jaguars, Amur leopards, snow leopards and North American pumas. By 2016, the Cat Complex housed only about fourteen big cats, as the zoo began displaying the big cats in more integrated settings like the African Grasslands exhibit.

When the Cat Complex opened, it was state-of-the-art, giving the animals the freedom to roam inside or outside within their caged areas so zoo visitors could see them from either inside or outside. Most of the enclosures include logs where cats can sharpen their claws, stimulating their instincts and contributing to their good health. Zookeepers place spices, perfumes or colognes in their enclosures when they are cleaned to sharpen the cats' sense of smell and encourage the felines to investigate odors. Afterward, cats re-mark their territory with urine.[70]

For a time, white tigers were the facility's most noted occupants, although they have since been phased out. At one point, the Henry Doorly Zoo had seven of the rare animals, including a spectacular male named Ranjit. The

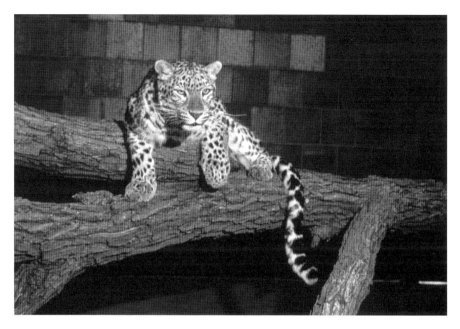

The Henry Doorly Zoo's Cat Complex could house up to one hundred large cats, but it never held more than eighty-five. *Courtesy of Dr. Lee Simmons.*

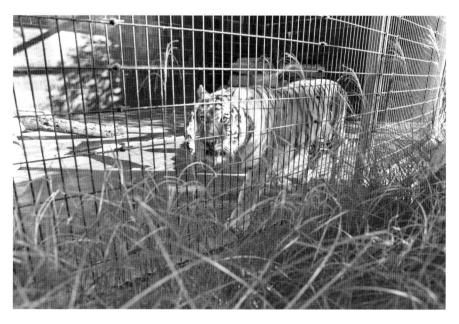

A tiger enjoys the outdoor section of its home in the Cat Complex. *Photo by Mary Plambeck Cook.*

National Zoo in Washington, D.C., had loaned him to the Henry Doorly Zoo to breed more white tigers. The zoo also had former circus tigers with a recessive white gene that Simmons had bought from a cash-strapped Hungarian "baron" when the Shrine Circus came to Omaha.

The baron discovered the gene on the day the female delivered a white tiger cub shortly before she was due to perform. He hadn't even realized she was pregnant. Word of the birth spread, and when the circus came to Omaha, Simmons made an offer that the owner could not refuse, paying for the tigers with a large check from the zoo. The baron went quickly to an Omaha bank to cash it, but since he was rough-looking, a bank employee wondered if the check was real. The employee refused to cash it until he had called Simmons to confirm its authenticity.[71]

POPULAR ANIMALS

The Legendary Fu Manchu

The orangutan Fu Manchu was a talented "engineer" whose antics kept his keepers busy. *Courtesy of Dr. Lee Simmons.*

By the 1970s, the zoo's population included some memorable animals, none more so to his keepers than Fu Manchu, an orangutan who was "a natural mechanical engineer."[72] Fu Manchu, who was also an escape artist, figured out how to break open the padlocks to the orangutan exhibits and let the other occupants out. When the zoo installed bigger and stronger padlocks, he mastered those, too, even discovering how to stick a bent wire between the doorjamb and the lock to open the enclosure. Ironically, said Simmons, Fu Manchu never left the orang house but would sit and wait for zookeepers to catch the others and return them to the enclosure.

OTHER IMPROVEMENTS AND A TRAGIC FIRE

The Owen Sea Lion Plaza and Cat Complex were not the only improvements made during the 1970s. Other upgrades included:

- A diet kitchen and educational classrooms
- A second Omaha Zoo Railroad locomotive to keep up with the demands of the zoo's growing attendance
- Reptile exhibits, including a fifteen-foot king cobra in the middle of a museum building
- Additional rare animals, such as gaur, sable antelopes and musk ox
- Expansion of the children's zoo, including construction of the Aksarben waterfall

A fire in the zoo's hospital-nursery in January 1979 was a grim reminder of the dangers that inadequate facilities could pose to animals. It killed two red-tailed hawks, a golden eagle, a macaw, a margay (an ocelot-like cat) and ultimately a young gaur. The hospital-nursery was in a building similar to a double-wide house trailer, and in extremely cold weather, zookeepers used bales of hay as insulation to keep the pipes from freezing. A propane heater ignited the hay, sparking a blaze that workers spotted while they were having lunch. They managed to rescue a three-year-old orangutan and a four year old gorilla, but both were in critical condition due to smoke inhalation. Pediatricians from Children's Hospital gave advice that helped save the two. It took firefighters three hours to extinguish the blaze.[73]

4

BIRDS, BEARS AND THE WILD KINGDOM

The 1980s

As the 1980s opened, the Henry Doorly Zoo's collection of animals was growing rapidly, with a constant need for new and renovated structures to house popular species, such as giraffes. The fire that destroyed the old hospital-nursery was a reminder of why improvements were necessary. Fortunately, by the 1980s, the zoo had become a favorite recipient of major gifts from local businesses and philanthropists.

In 1981, the zoo opened a complex for giraffes and other hoof stock. This was a significant upgrade for the giraffes, which had been living in the converted Riverview Park picnic pavilion that had housed elephants prior to their move to the Eppley Pachyderm Hill in 1968. The old picnic pavilion would be converted two more times after the zoo opened its next significant major exhibit: the Lee G. Simmons Free Flight Aviary.

THE SIMMONS AVIARY

When Mary Traudt, who had been a partner in the Lozier Corporation, asked Simmons to suggest a major project that she might fund for the zoo, he suggested a new animal hospital. Since the fire at the old hospital-nursery, he had sometimes been forced to treat sick animals in a men's room, since there was no place else to do it. He invited Traudt to the zoo for a guided tour, and over the course of the visit, Simmons waved his

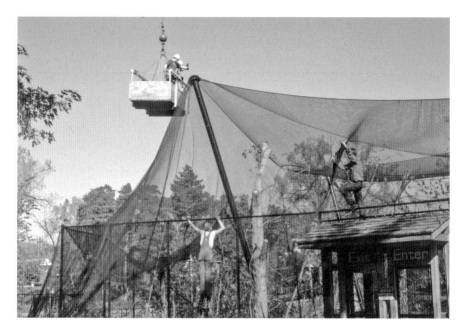

The Simmons Free Flight Aviary is one of the largest anywhere. This photo shows its mesh ceiling. *Photo by Mary Plambeck Cook.*

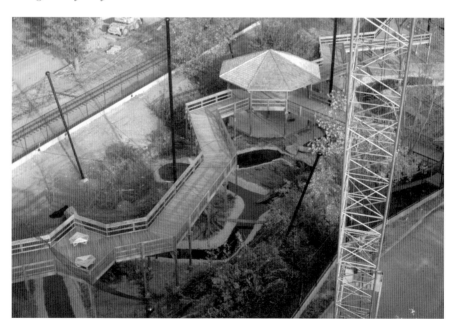

This aerial shot of the Simmons Free Flight Aviary shows its size and configuration. *Courtesy of Dr. Lee Simmons.*

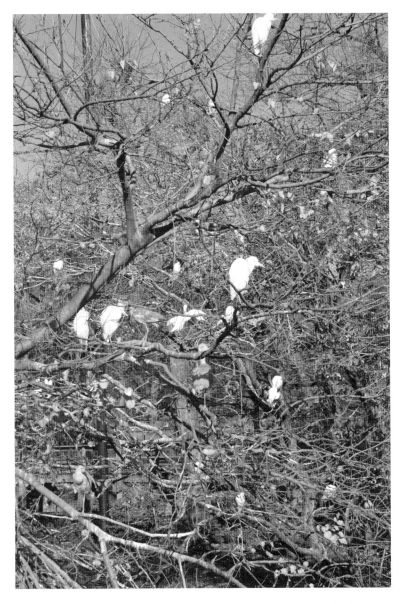

Flamingos and other birds enjoy flying freely and alighting on trees in the Simmons Aviary. *Photo by Mary Plambeck Cook.*

arms toward the ugly old Riverview Park gully that ran through the zoo. It was filled with junk like old refrigerators that people had dumped after the old park had closed for the night. Simmons told Traudt that if the junk were cleaned out, the gully would make a great walk-through aviary. This was bad news for a new hospital but good news for birds.

Traudt told Simmons that she knew he wanted a hospital, but she wanted to build the aviary. "I said that makes it simple. We'll build the aviary," said Simmons.[74] Without seeking his permission, Traudt asked the zoo's board to name it for Simmons. Before construction could begin, the junk and muck had to be cleaned out of the gully. Underneath the muck, the zoo found a four-foot-deep layer of hard clay that would support the pillars for the foundation and the poles, cables and fabric cover that formed the aviary.

Today, an eight-thousand-pound nylon mesh roof with a protective coating to prevent accumulations of ice and snow covers the 1.3-acre aviary. The eight-hundred-foot long structure rises to seventy-five feet at the center. The zoo chose slightly larger opening nylon instead of wire mesh because it sheds ice and snow and is more economical to replace every five to eight years for about $60,000 than the wire mesh, which would cost $300,000 to replace every twenty to twenty-five years.[75]

The aviary (second largest in the world) houses over five hundred birds, including flamingos, ducks, swans, egrets, ibises and storks. Visitors enter it through spring-loaded doors and a curtain of vertical plastic chains. The movement of the chains keeps birds away from the entrances and from escaping. Inside, there are one thousand feet of wooden walkways. There are no cages, and visitors have to look carefully to see birds from around the world in the trees and foliage or enjoying the streams and pools flowing with about 400,000 gallons of water a day pumped from a well dug into a hill beyond it. Outside the aviary, peacocks and native turkeys wander the zoo grounds. Since about half the birds require indoor shelter during the winter, the zoo houses the flamingos and ibises in a new Avian Support Center.[76] Others formerly lived in the converted pavilion that once housed the giraffes, and now they are in a new bird winter quarters building.[77]

ADDITIONAL 1980s IMPROVEMENTS

While the zoo contemplated its next major exhibit after the aviary, it opened a seventy-thousand-gallon saltwater aquarium in the old museum.

"We built our first small aquarium in the 1970s," said Simmons.[78] This had consisted of one-hundred-gallon free-standing tanks in the middle of the room that housed the Elgin Gates stuffed animal collection. The second aquarium was in the same space but had seven exhibits with a total of seventy thousand gallons. These were a significant improvement and housed the zoo's first sharks. These are still used in today's much larger aquarium.

A year later, the Owen family gave its name to the renovated gorilla and orangutan buildings that had been part of the original renovations at the Henry Doorly Zoo in 1965. In 2005, Hubbard Gorilla Valley and Hubbard Orangutan Forest were added to these buildings.

In 1986, World-Herald Square opened above the children's zoo, as did First Tier Wolf Woods, a fenced-in wooded area housing maned wolves and giant foxes from Patagonia.

MUTUAL OF OMAHA'S WILD KINGDOM PAVILION

Mutual of Omaha had built its national brand by sponsoring an important national television show featuring wildlife. *Wild Kingdom* told the stories of animals worldwide. It was popular in Omaha, as was Simmons's own weekly program, *Zoo Time*, on KETV, which featured animals from the Henry Doorly Zoo. Since Mutual of Omaha and the zoo were both involved in educating the public about animals, a partnership seemed logical.

The Mutual of Omaha Wild Kingdom Pavilion originated with a request to V.J. Skutt, head of Mutual of Omaha, to contribute to building a new zoo's entrance at the south end of the parking lot. The Mutual of Omaha board agreed to assist with the project and also said it would sponsor an educational building honoring Skutt. The 1987 spring membership drive, with the theme "Go Zoo U," also helped finance the $4 million project.

The Mutual of Omaha Wild Kingdom Pavilion—just inside the main entrance—is the first major building that many guests visit. It helps orient them to the zoo and offers a range of educational programs and activities. The twenty-one-thousand-square-foot building originally housed three classrooms, an auditorium and many small interactive exhibits. In 2007, the

zoo and Mutual spent $1 million renovating the building into an Exploration Station that is still a magnet for school groups. Features include an Explorer Zone Classroom, a Discover Biodiversity area, a 312-seat auditorium, numerous animal displays and an interactive animal demonstration area. There are daily educational programs, such as wildlife shows and meetings with animal handlers. Now many interactive exhibits have been computerized.[79]

DURHAM'S BEAR CANYON

The old Riverview Park Zoo had featured bears living in grottos constructed at the turn of the century. The renovated bear display was the first major exhibit to open in the Henry Doorly Zoo. However, by the late 1980s, the zoo's growing collection of bears needed better quarters that would also improve public viewing. In 1989, it opened the renovated $1.4 million Durham's Bear Canyon, named in honor of the family of Charles and Margre Durham. Charles Durham headed HDR Incorporated, a major Omaha engineering company founded by Margre Durham's father. Margre Durham, said Simmons, was the family's zoo enthusiast, having volunteered for the membership drive and Zoofari. She also was the driving force behind other Durham donations, such as the TreeTops Restaurant and Durham Lodge.[80]

Bear Canyon features a polar bear swimming in a thirty-thousand-gallon pool that can be viewed from above or below the water. Other residents of the canyon include sun bears, Andean bears and American black bears. The zoo keeps bears mentally alert by such things as freezing fish inside blocks of ice so the polar bear must find a way to retrieve its favorite treat—an exercise that visitors enjoy.[81]

DOORLY'S PRIDE

The 1980s ended with two landmarks: 1) The zoo began constructing the $15 million Lied Jungle that would open in 1992 and gain international acclaim. 2) It installed *Doorly's Pride*, a massive bronze sculpture of a pride of twelve lions just inside the main entrance. Bob Guelich, a noted artist

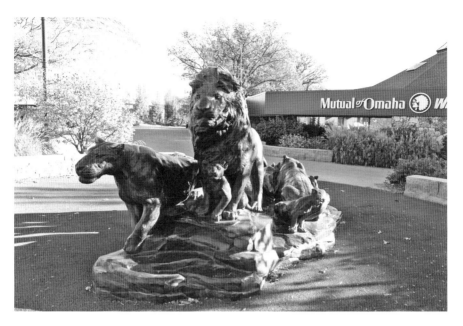

Doorly's Pride, one of the zoo's many animal sculptures, is one of the first sights that greets visitors when they come through the main entrance. *Photo by Mary Plambeck Cook.*

Small sculptures of monkeys enliven the plaza just outside the entrance gates where guests wait for the zoo to open. *Photo by Mary Plambeck Cook.*

Donors to the Berniece Grewcock Butterfly and Insect Pavilion are recognized on individual butterflies outside the building, just as donors to the Walter and Suzanne Scott Aquarium are honored on individual fish inside the building. *Photo by Mary Plambeck Cook.*

Animal sculptures like these of butterflies throughout the zoo's grounds help create a special atmosphere. *Photo by Mary Plambeck Cook.*

from San Antonio, Texas, created the statue that was donated by Harry A. Koch and his wife, Gail, granddaughter of Mr. and Mrs. Henry Doorly. The sculpture depicts lions situated on a base that resembles a natural rocky "landscape."[82] Children often spend their first (or last) few minutes at the zoo climbing all over it and being photographed on it. When Omaha's Henry Doorly Zoo and Aquarium re-did its main entrance under the 2010 master plan, it rotated the sculpture so it would still be one of the first things that guests see.

Doorly's Pride is one of many animal sculptures throughout the zoo grounds. Some, such as the metal and colored glass sculptures of butterflies or the gorilla family, are located just outside the exhibits of the species they depict. Others, like the giant polar bear sculpture near the main entrance, suggest what visitors will soon see. The zoo also includes sculptures of mammoths and other prehistoric animals that lived in Nebraska, and the Alaskan Adventure water exhibit that opened in 2016 contains sculptures of the sea lions, puffins, orcas and salmon there, including a giant sculpture of a humpback whale. The zoo views sculptures as yet another way to teach the public about animals.

A JUNGLE AND AN AQUARIUM

The 1990s

In the 1990s, the Henry Doorly Zoo gained international recognition for creating two blockbuster ecosystem exhibits that are still among its marquee attractions: 1) In 1992, it opened the Lied Jungle, the world's largest indoor rainforest at the time. 2) In 1995, it opened the Walter and Suzanne Scott Kingdoms of the Seas Aquarium, which is still the nation's largest aquarium housed at a zoo. It has been added to the zoo's full name: Omaha's Henry Doorly Zoo and Aquarium.

Both exhibits were so popular that they significantly increased zoo memberships and attendance, and visitors initially had to get timed tickets to tour them. Both immersed zoo goers in environments that they would never otherwise experience and exposed them to animal and plant species far from the Nebraska prairies.

However, the zoo did not ignore the animals of its native region. In 1998, it opened the Lee G. Simmons Conservation Park and Wildlife Safari half an hour from Omaha. It showcases species native to Nebraska, such as buffalo, elk, wolves and deer in a drive-through location where the animals roam free as they did in pioneer times.

THE LIED JUNGLE

When visitors enter the Lied Jungle, the first thing that hits them is the musty odor of the jungle from leaf mold, along with its heat, humidity and

dripping water. The tropical environment is so realistic that some Vietnam War veterans have even experienced flashbacks.[83] From the jungle trail through the exhibit's base, visitors can look up to see tropical birds flying seven or eight stories overhead and monkeys swinging from trees, both real and manmade, that are almost indistinguishable. On the upper walkway, guests can explore the mid-canopy levels of rainforests of Africa, Southeast Asia and South America, cross a swaying rope bridge and watch water cascade down a fifty-foot waterfall.

It's no wonder that visitors have come from all over the country and the world to see this wonder that has been honored as one of the world's best zoo exhibits.

Origins

Simmons conceived the idea for the exhibit on his many wildlife conservation trips and safaris to jungles and rainforests in Africa, South America, Thailand, Malaysia and Vietnam. "My idea was that very few people from Omaha will ever get to a jungle or a tropical rainforest. We wanted to give them a total immersion experience."[84]

There were few models for the major exhibit that Simmons envisioned, only a few smaller jungle exhibits and a few tropical rainforest gardens at leading botanical gardens such as Kew Gardens in London that he and his planning team visited. Only Jungle World at New York's Bronx Zoo, which opened in 1985, is somewhat similar to the Lied Jungle and nearly as large at eight-tenths of an acre.

While these were of modest assistance, the project would be a groundbreaker for zoos worldwide. Simmons enlisted the help of Omaha's Stanley J. How architectural firm, which had designed other major buildings for the zoo, including the aviary, the giraffe exhibit and the Wild Kingdom Pavilion. He also had to find funding for an estimated $25 million project, including the cost of a restaurant, greenhouse and educational facilities. The jungle would be—by far—the zoo's most ambitious undertaking to date.

Tyler Gaines of Omaha, an attorney for the late Ernest Lied, urged Simmons to get acquainted with Lied's close business associate Christina Hixson. Lied, a former Omaha car dealer who had become wealthy by developing real estate in Las Vegas, had left his $100 million fortune to his foundation. Hixson was its sole trustee.

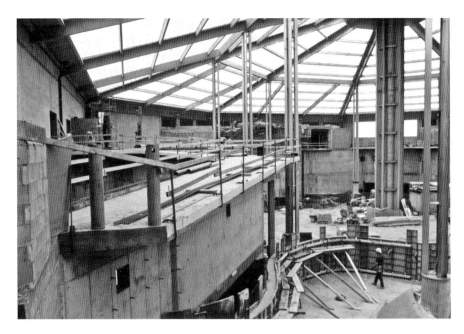

These photos show the Lied Jungle under construction. Note its octagonal shape. *Courtesy of Dr. Lee Simmons*.

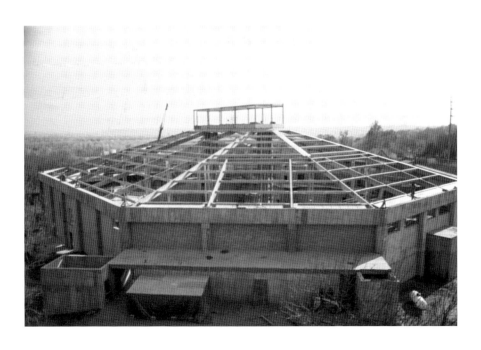

Planting vegetation was an important part of constructing the Lied Jungle. *Courtesy of Dr. Lee Simmons.*

"I started by writing a proposal to Chris and followed up with a letter every six months for years," said Simmons.[85] Persistence paid off, partially because Hixson wanted to fund an "extremely significant" project. In late 1988, she gave Simmons permission to begin planning the jungle while reserving a commitment on how much of it the Lied Foundation would fund.

The zoo located the building on a fifty-foot-deep gully near the main entrance that was an eyesore dating back to Riverview Park. Plans called for a building with eight corners that would be about eighty-five feet tall (equivalent to eight stories) from the bottom of the gully to the roof. The zoo had drilled holes in the eight corners and put fifty-foot poles in place so that Hixson could see the building's size and layout when she visited to finalize the project. A brilliant negotiator and experienced property developer, Hixson was determined to control costs. She told Simmons that the Lied Foundation would donate $15 million—the zoo's largest-ever donation—but said that the zoo would have to eliminate parts of the project and find other donors to pay for parts of it. She said she wanted everything she had been shown in the main part of the project, the jungle. Hixson also required the zoo to plan funding long-term maintenance. Simmons agreed to find other donors for the restaurant, greenhouse and educational space.

The Building

Creating the Lied Jungle was a challenge because it was so revolutionary. Simmons, architect Stan How and engineers from Kiewit Construction did all the planning in-house. The jungle environment demanded authentic trees and tropical plants similar to those in the photos that Simmons had taken on his trips. But the tropical vegetation couldn't just be planted in the middle of a modern building if visitors were to experience being immersed *in* a jungle, not just looking at one. The answer was disguising structural elements—such as manmade trees and rocks of fiberglass, cement and metal—and blending them so skillfully with real trees and plants that visitors could scarcely tell the difference. The jungle employs a manmade South American kapok tree and a Southeast Asian dipterocarp tree as the main supports for the roof. Mechanical devices, such as air ducts, filters and light fixtures, are hidden inside the trees, walls and rocks.

Adding to the complexity, Simmons wanted visitors to sample rainforests from three continents in one building. To accomplish this, the Lied Jungle is divided into three distinct ecological areas, each of which features animals, trees and plants from those regions. All are clearly marked by

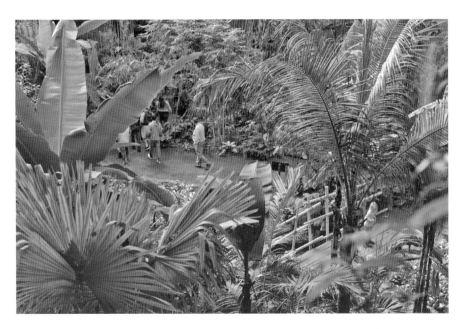

Guests walking along the floor of the Lied Jungle experience the sights, smells and atmosphere of real rainforests. *Photo by Mary Plambeck Cook.*

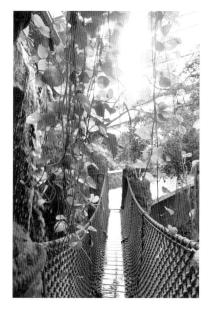

This upper-level rope bridge in the Lied Jungle sways just as real rainforest bridges do. *Photo by Mary Plambeck Cook.*

From the floor of the Lied Jungle, guests look upward to dense foliage and other features of a rainforest, such as these hanging vines. *Photo by Mary Plambeck Cook.*

signs along walkways, but there are no jarring separations as region gives way to region.

The **Asian Rainforest** features a swaying rope suspension bridge that leads to a nocturnal cave with small animal exhibits. Asian animals on display include the Malayan tapir, gibbons and small-clawed otters. The Henry Doorly Zoo is one of two accredited zoos to house François' langurs, which can be found in Vietnam. Saki monkeys are found in only two zoos and in the South American rainforest. Plants include the coconut palm, black pepper, teak tree, pongam tree and many species of bamboo, plus staghorn ferns and phaleonopsis orchids.[86]

The **African Rainforest** features a variety of primates and birds, as well as spotted-neck otters and pygmy hippos that swim in ponds on the jungle's floor. Visitors also can get eye-to-eye with hippos through an underwater viewing cave along the jungle trail. African trees and plants include the tamarind, cola nut tree, African tulip and African sausage trees. There also are plants indigenous to Madagascar, such as the spindle palm, triangle palm, travelers palm and angraecum orchids.[87]

The highlight of the **South American Rainforest** is a fifty-foot waterfall, the second largest in Nebraska. Visitors walk behind the waterfall (getting slightly damp in the process) to Danger Point, from which they can look down on the entire rainforest. Featured animals include spider monkeys that share an

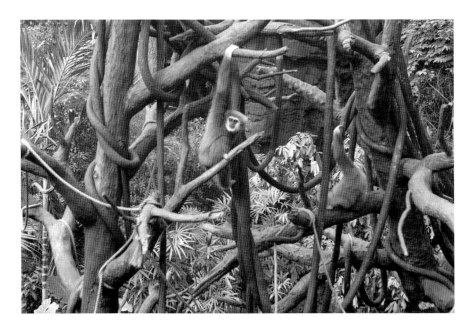

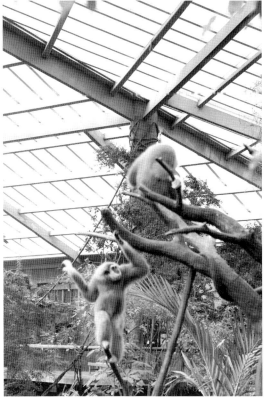

Playful gibbons like these delight visitors as they swing from trees and vines in the Lied Jungle. *Photos by Mary Plambeck Cook.*

island with tapirs and capuchin monkeys, and the black howler monkey moat provides a home for huge South American red-tailed catfish, pacu and seven-foot-long arapaima. Vegetation includes the queen palm, the building's largest palm, along with a chocolate tree, all-spice tree, guava and South American mahogany tree and many philodendrons and epiphytic orchids.[88]

Other Features

Only about 53,000 square feet of the Lied Jungle's 123,000 total jungle square footage of floor space is devoted to the exhibits that visitors see. Animal holding spaces and mechanical spaces are included in the 35,000 feet of behind-the-scenes display management space. As part of its effort to reduce costs, the zoo salvaged the greenhouse from a city sludge-drying facility and moved it to the zoo for use at the horticultural department rather than build a new one.

When Hixson told Simmons to find additional donors or downsize the project, he turned to Charles and Margre Durham to underwrite the Durham TreeTops Restaurant adjacent to the jungle. This tropical-themed cafeteria gave the zoo a badly needed eating facility. Previously, it had only one concessions stand.

The zoo's education department is located just below the restaurant, and it is responsible for numerous activities, including docents, campouts, Scout classes, nature classes, speaker's bureau and more. It helps educate the public about the need to conserve the world's rapidly disappearing rainforests.[89] Most of the education functions will be housed in a new facility scheduled to open in the summer of 2017. Under the zoo's master plan, it will be housed in the Children's Adventure Trails area.

Public Reaction and Awards

Public response to the Lied Jungle was wildly enthusiastic. Attendance rose from about 680,000 in 1988 to about 1.38 million in 1992, and the zoo sold a record 51,437 memberships. *Omaha World-Herald* headlines from the first week in April 1992 give a sense of the excitement about the opening:

- "Lied Jungle Promises Surprises at Every Turn Going to the Jungle" (April 3, 1992)

- "Doorly Zoo Is Preparing for (Lied) Jungle Fever" (April 3, 1992)
- "Homo Sapiens Invades Lied Jungle" (April 5, 1992)

Visitors poured in from throughout the region, and the exhibit attracted national and international visitors. Other zoos studied the project.

"This was our first internationally significant exhibit," said Simmons. "It was the biggest and best of its kind in the world."[90] The Lied Jungle has received numerous major awards, including:

- *Family Life Magazine* named it the single best zoo exhibit in the country in 1994.
- The American Association of Zoological Parks and Aquariums gave it the 1993 Significant Achievement Award for Exhibit Design in 1993.
- *Time* magazine called it one of the top ten designs in all categories in the world in 1992.
- The National Society of Professional Engineers cited it as one of the top eight U.S. engineering accomplishments in 1992.

The opening of the Lied Jungle led directly to the zoo's next blockbuster project: the Walter and Suzanne Scott Kingdoms of the Seas Aquarium.

THE WALTER AND SUZANNE SCOTT KINGDOMS OF THE SEAS AQUARIUM

As Simmons and zoo society chairman Walter Scott stood together outside at the dedication of the Lied Jungle, Scott asked Simmons what big project he wanted to begin next. Since 1985, the zoo had featured a saltwater aquarium that held seventy thousand gallons of salt water. "I said I would like to do a real aquarium. Walter said he liked aquariums so 'Let's do it.' That's how the aquarium came to be."[91] Scott, who at the time was CEO of Peter Kiewit Sons' Incorporated, had joined the Omaha Zoological Society Board in 1975 and served as its president and chairman before becoming president of the Omaha Zoo Board in 1986. As Omaha's most influential civic leader and one of its leading philanthropists, his support could virtually guarantee a project's success.

The Walter and Suzanne Scott Aquarium is one of the zoo's most popular attractions. *Photo by Mary Plambeck Cook.*

Simmons, who had supervised the aquarium at the zoo in Columbus, Ohio, before coming to Omaha, had long dreamed of replacing the zoo's second aquarium with a larger one, even though it was functioning well. The new aquarium would hold 1.3 million gallons. He and How Architects, along with engineers from Kiewit Construction, began planning for the new exhibit by visiting major aquariums around the United States to learn what mistakes to avoid.

The new aquarium cost $16 million and was built on the same site as the old. It reused the existing tanks after zookeepers emptied them and moved the fish to other public aquariums.

The Building

Simmons wanted visitors to experience aquatic environments from the tropics to polar regions and to feel as if they were walking on the ocean floor with fish swimming overhead. But a great aquarium begins with addressing water management requirements invisible to visitors. "The secret to a good aquarium is water quality," said Simmons. "Clarity is important for visitors to see the fish [, and] water quality is important for

the survival of the fish. When we opened, we had the best life support for our animals of any aquarium."[92]

At the Scott Aquarium, visitors only see about half the water that circulates, while there's a 5:1 ratio for delicate species like corals. This dilution factor of water circulating in the tanks makes a major difference in the quality of the water that fish breathe while they are swimming and keeps them from polluting the water with their own waste.

The Scott Aquarium takes guests on an enthralling tour of marine environments around the world, beginning with a five-hundred-gallon tide pool touch tank inside the entrance that features anemones, starfish and urchins. It is staffed by docents and allows visitors to connect with nature hands-on.[93] Some guests don't stop at the touch tank in their eagerness to visit the displays of penguins and puffins and stroll through Shark Reef's spectacular underwater acrylic tunnel.

Penguins and Puffins

Sue Scott asked if the aquarium could feature penguins. Simmons told her all it would take was the money, which was forthcoming. Visitors can view more than eighty-five Antarctic penguins through a sixty-foot-long, twenty-five-foot-high window extending above and below water to observe their antics both on land and in the thirty-five- to forty-degree water. The exhibit includes rock cliffs, salt water and man-made snow. The exhibit's four snow machines can produce twenty tons of snow per day. Penguin species include king penguins, gentoo penguins and small rockhopper penguins. A separate above-and-below water exhibit showcases tufted and Atlantic puffins and common murres and features a twenty-foot-high cliff nesting site. These exhibits are especially popular with children.

Shark Reef

The aquarium's signature exhibit is Shark Reef, in which visitors enter a dim seventy-foot-long acrylic tunnel that takes them past coral heads, canyons and caves. The tunnel, at the bottom of a seventeen-foot-deep exhibit, gives visitors the experience of walking in dim light along the ocean floor as large sandbar sharks, zebra sharks, schooling crevalle jacks and stingrays swim overhead and on two sides of them. The sharks swim in 900,000 gallons

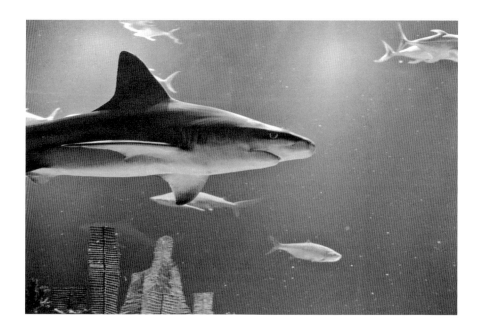

This page: Visitors walking under Shark Reef, a seventy-foot-long acrylic tunnel, look upward to swimming schools of sharks. *Photos by Mary Plambeck Cook.*

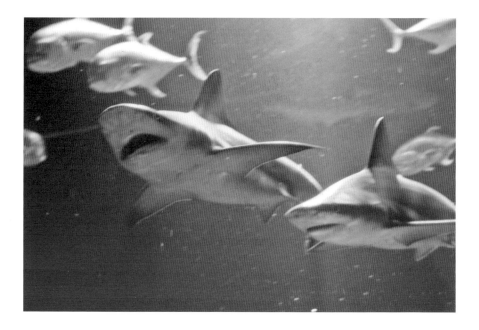

of circulating salt water kept at seventy-seven degrees. An underwater cave with a large flat viewing window offers another way of experiencing the ocean depths.[94]

Other Exhibits

While the penguins and sharks are the most spectacular marine life at the aquarium, other major exhibits include an Amazon River freshwater tank housing stingrays, piranhas, armored catfish, pacu, birds and special lighting. There are four exhibits that highlight Omaha's Henry Doorly Zoo and Aquarium's conservation work with coral reefs while featuring many species of reef fish along with a large number of coral species. Visitors can see many invertebrates, such as jellyfish, octopus, giant clams and sea stars. Six tanks feature animals that the aquarium staff has chosen because of their special interest.[95]

A child has a close encounter with a swimming turtle at the aquarium. *Courtesy of Andrea Hennings.*

Public Enthusiasm

The opening of the aquarium helped the zoo set both attendance and membership records. Creative headline writers saluted the exhibit with lines like "Dawning Age of Aquarium" (April 13, 1995). That article reported attendance was running 27 percent ahead of the previous year. The final attendance for the year was over 1.6 million, a record that stood for years. Meanwhile, the zoo sold 73,387 family memberships, nearly 20,000 more than the year before and more than 18,000 higher than the record set in 1993. Drive chairman Lynda Thomas said that "people just couldn't wait to get in [the aquarium]."[96]

In 2012, the aquarium and Sea Turtle Café received a $6.5 million facelift that included installing nine new exhibits, new carpet, air-handling systems, ceilings, wall finishes, flooring interpretive graphics and digital monitors in addition to special lighting, curved wave walls and wider paths. A $4 million conference and education center was added. Although the Scotts were the largest donors in building the aquarium, numerous other contributors also are recognized on a wall of fish bearing the names of donors.

Lee G. Simmons Conservation Park and Wildlife Safari

In the late 1990s, zoo foundation board member Harold W. Andersen, former publisher of the *Omaha World-Herald*, was encouraging the zoo to feature more of Nebraska's native animal species, such as bison, elk, deer and sandhill cranes. Unfortunately, many of these did not adapt well to conventional zoo display, according to Simmons. About this time, another foundation member, Bill Grewcock, offered to give the zoo some farmland he owned near Ashland, Nebraska, about twenty miles west of Omaha. While the property wasn't very good farmland, it would make for a great habitat and was conveniently located off Interstate 80 near Platte River and Mahoney State Parks.

"My original thought was to use the land for off-site breeding, not display," said Simmons.[97] However, Eugene Mahoney, a former head of the Nebraska Game and Parks Commission who had become the zoo foundation director, urged that the site be used to display Nebraska animals in the wild much as Lewis and Clark would have seen them.

Today's conservation and safari park combines the two ideas. When the $3.5 million park opened in 1998, it focused on large American species like bison, elk, black bears, deer and sandhill cranes. It now includes the Eagle Aviary, with bald eagles, white pelicans, waterfowl and a golden eagle. The Crane Meadows twenty-eight-foot viewing tower formerly housed news media cameras at the old Rosenblatt Stadium. There are sculptures, hiking trails, wolves, bears and a bridge.

The zoo also uses the site for breeding cheetahs, housing imported animals during quarantine and quartering animals displaced by construction until they can return to their permanent homes at the zoo. The park draws about 140,000 visitors a year.[98]

Other Improvements

Other significant additions to the zoo during the 1990s included the Lozier IMAX 3-D Theater, which opened in 1997. Allan Lozier, head of Lozier Corporation, funded it partially from his love of technology, said Simmons. It shows primarily nature films and is free to zoo members.[99]

In 1998, the Garden of the Senses opened adjacent to the old Riverview Park picnic pavilion where birds were housed during the winter months. Extensive renovations to the structure were completed in 2014 to house preschool classrooms and a multiuse space. The $1.8 million garden was designed to allow everyone, including people with vision problems, to enjoy a sensory experience at the zoo. The garden is filled with more than 250 different fragrant species of herbs, perennials and trees as well as flowers. Braille identification signs help visually impaired guests enjoy the garden. Plants and sculptures can be touched and "seen with your fingertips," while sounds include the chirping and singing of birds and the splashing of fountains.[100]

Natural beauty has replaced the rubble left from tearing down the old Greek pavilion from the 1898 Trans-Mississippi Exposition that was moved to Riverview Park at the turn of the last century.[101]

DESERT DOME

The 2000s

As visitors approach Omaha's Henry Doorly Zoo and Aquarium, the world's largest glazed geodesic dome—some fifteen stories high—shimmers majestically in the distance. The $31.5 million Desert Dome would be spectacular even if it were empty. However, it houses two vastly different exhibits that are as amazing as the building itself: 1) The world's largest indoor desert exhibit; 2) The world's largest nocturnal zoo exhibit.

The dome, which opened in 2002, immerses visitors in re-creations of three of the world's major deserts: Africa's Namibian Desert, the Red Center of Australia Desert and the Sonoran Desert in the American Southwest. They see not only a unique collection of desert animals but also huge rock formations and a wide array of desert vegetation.

In the lower level Eugene T. Mahoney Kingdoms of the Night exhibit that opened in 2003, visitors experience the eerie world of nocturnal animals, including numerous species of bats and snakes. They walk through a wet cave complete with dripping stalagmites and stalactites and follow a boardwalk around the world's largest indoor swamp: a quarter of an acre featuring alligators, beavers, swamp trees and plants and the piped-in sounds of frogs and alligators. Emerging into the midwestern daylight, most would agree that Dr. Lee Simmons exposed them to two more "eco-systems from around the world that they wouldn't otherwise get to experience."[102]

In addition to these two major exhibits, during the first decade of the millennium, the zoo also created the Hubbard Gorilla Valley and Hubbard Orangutan Forest in addition to the Berniece Grewcock Butterfly and Insect

Pavilion. Meanwhile, it enhanced its animal conservation and research work with the opening of the Hubbard Research Wing expansion to the Grewcock Center for Conservation and Research.

CREATING THE DESERT DOME

As a native of Tucson, Arizona, who grew up in the Sonoran Desert before moving to Oklahoma City, Simmons was eager to show midwesterners the beauty of desert landscapes and the variety of desert animals and plants. "Most people here think deserts are desolate and devoid of life," he said. "But each desert has different plants and animals. Deserts are layered ecosystems and different from each other. They are much more than just sand and cactus."[103]

The three deserts featured in the dome vary greatly in plant and animal life and topography. Simmons and architect Stan How used photos to re-create distinctive features of each. They also visited other zoos that had smaller desert exhibits to learn what mistakes to avoid, just as they had

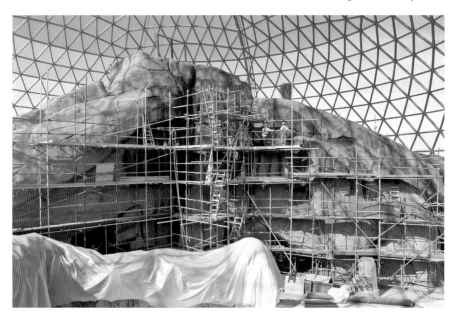

Above and opposite: These photos show the Desert Dome under construction, including the massive rock formations that awe visitors. *Courtesy of Dr. Lee Simmons.*

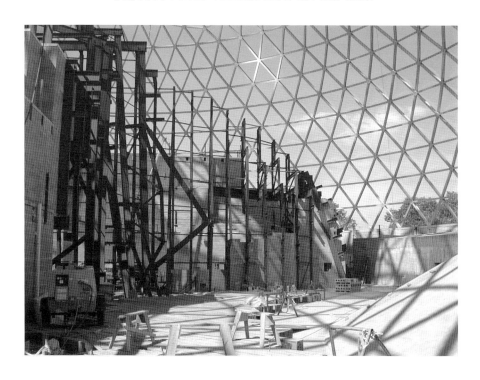

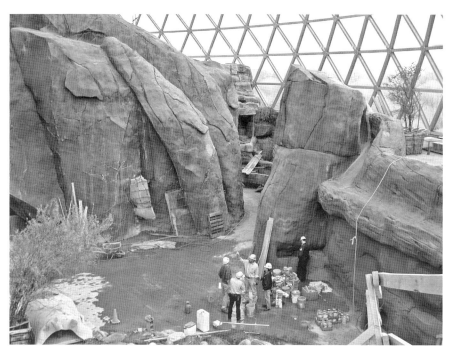

done for earlier projects, like the Lied Jungle and the Suzanne and Walter Scott Aquarium.

They decided that a geodesic dome offered the best solution for re-creating the light and climate of a desert without exposing visitors to extreme heat. Other zoos had used the domes for smaller desert exhibits, but no one had attempted something massive like Simmons and How envisioned. Allan Lozier, head of Omaha's Lozier Corporation, became the largest donor because he was fascinated by the technical challenges of creating such a revolutionary building.

"Our geodesic dome is a half sphere with the roof way above the line of vision so as you go through the exhibit, the dome disappears."[104] The Desert Dome consists of 1,760 tinted acrylic panels in three different shades as well as clear glass. From a distance, the shadings blend so that the dome appears to be uniformly translucent. However, the shadings of the panels allow for maximum shade in the summer and maximum light in the winter. A computer program simulated the height of the sun during each season to determine panel locations, with the clearest on the sides for more light in the winter.

Although the dome appears to almost float, it is one of strongest buildings at the zoo, as the ceiling of the Kingdoms of the Night must also support the extremely heavy desert exhibits with their massive rock formations and layers of sand. It contains more than half a million pounds of steel reinforcement and over ten thousand tons of concrete. The dome's structure helps maintain the heat and light levels required for animal and plant health and the comfort of visitors. Ground level temperatures are kept at 72 to 75 degrees Fahrenheit, but temperatures at the top of the dome can reach 140 to 150 degrees Fahrenheit in the summer as heat rises. A mechanical head house at the top of the dome contains the heat recovery units used for climate control. During winter, reclaimed heat helps warm the dome, and during the summer, exhaust fans and louvers expel hot air.

As part of the construction project, the zoo built a refrigeration plant that reduces air-conditioning costs. The plant freezes twenty-eight large tubs of ice at night to air condition the dome, Expedition Madagascar and other zoo buildings, including the Lied Jungle, during the day. Cold water running from the tubs through pipes cools the buildings. An irrigation and drainage system throughout the dome waters plants without rotting their roots, and soil is heated or cooled in different areas. Temperature sensors throughout the building monitor individual exhibits.[105]

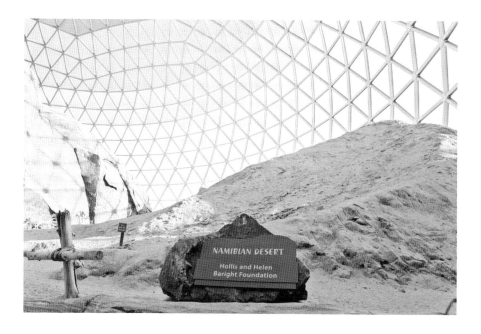

Deserts are far from uniform, as these displays of the Namibian Desert and Sonoran Desert in the Desert Dome illustrate. *Photos by Mary Plambeck Cook.*

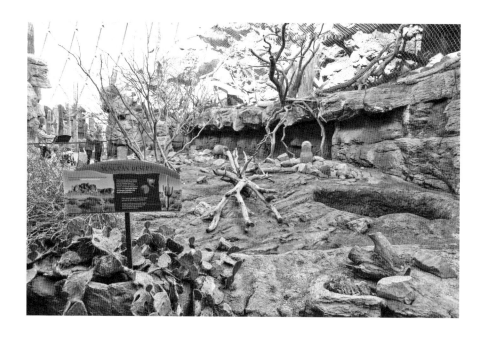

VISITING THE DESERTS

When visitors enter the Desert Dome, they step into a rotunda whose walls introduce them to the distinctive features of each of the three deserts. The Sonoran Desert description notes that it contains a display of giant endangered Saguaro cactus like those featured at Saguaro National Park near Tucson. These descriptions alert visitors about differences to notice as they move from site to site. Guests should plan for extra time to spot small desert animals.

The Namibian Desert

The Namibian Desert in southern Africa is the world's oldest and most biologically diverse desert. This exhibit features a thirty-foot-tall sand dune containing three hundred tons of red sand taken from a mine near Phoenix. Desert animals, including rock hyraxes, klipspringers and meerkats climb the cliff. Visitors also can view them in display areas of rocks and desert plants across from the cliffs. Some twenty-one reptile species from Africa and Australia live in a Desert Caves passage that leads to the Red Center of Australia Desert. These include such venomous snakes as death adders, a cape cobra and the inland taipan, the world's most venomous land snake.

The Red Center of Australia Desert

A replica of Ayers Rock, the world's largest monolithic rock, dominates this portion of the Desert Dome. There's also a copy of Wave Rock, a colorful granite overhang that looks like a waterfall. Children especially enjoy the playful wallabies but have to work to spot them.

The Sonoran Desert

Contrasting the Red Center with the Sonoran Desert illustrates the diversity of desert life and landscapes. The giant Saguaro cactus plants of the Sonoran Desert alert guests that they have left Australia for the American Southwest, complete with the world's largest indoor rattlesnake exhibit. Ocelots look on as peccaries wallow in the desert dirt. There are also flat prickly pear cactus,

fourteen species of reptiles and amphibians, Gila monsters and bearded lizards (both federally protected endangered species).

The Desert Dome Sun Room near the exit showcases newly hatched reptiles and amphibians and houses some of the zoo's conservation and research work with such animals.[106]

EUGENE T. MAHONEY KINGDOMS OF THE NIGHT EXHIBIT

In his travels to places like the rainforests of South America, parts of Africa, Southeast Asia and Borneo, Simmons often spent nights in the field observing nocturnal animals that only a few people ever see. Caves and the animals living in caverns also fascinated him. "There are so many interesting animals that people never see in daylight because they are only out at night."[107]

The hidden world of night animals, including frogs, bats, snakes, kangaroo rats, nutria and alligators, inspired what Simmons calls "our most unique experience": the Kingdoms of the Night.[108] The concept was so distinctive that explaining it to zoo donors to persuade them to back the idea was more challenging than previous major exhibits, such as the jungle and the aquarium.

"A lot of people understood the jungle and the aquarium, and Omahans get the idea of the southwestern desert, but almost no one understood what we were trying to do with the Kingdoms of the Night," said Simmons. "Walter Scott's comment was 'You're going to put in all those icky things; I don't like bats and snakes and spiders.'"[109] However, when the Kingdoms of the Night exhibit opened a year after the upper level of the Desert Dome, it was an instant hit with visitors, especially children, because no one had ever experienced anything remotely like it.

Planning the Kingdoms of the Night

Plans for the Kingdoms of the Night were coordinated with those for the deserts because the Desert Dome had to accommodate both. For example, mechanical systems for the two environments had to be integrated during construction. The zoo finished work on the Kingdoms of the Night a year after opening the Desert exhibit, giving it two blockbuster hits in a row.

As always, Simmons visited similar attractions, looking for ways to avoid problems. For example, when he stopped in Frankfurt, Germany, on his way

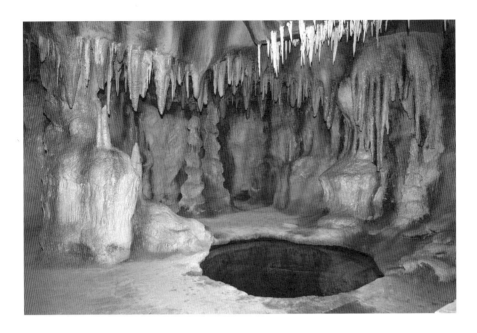

The Kingdoms of the Night exhibit features things most people would never see, like this wet cave drowning hole and a trapper's cabin in a Louisiana bayou. *Courtesy of Dr. Lee Simmons.*

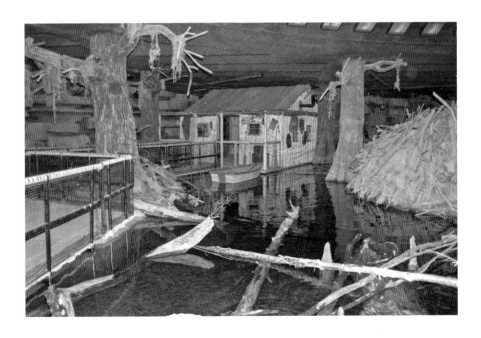

home from a business trip to Russia to see what was then the world's premier nocturnal exhibit, a pickpocket took his wallet and his airplane ticket because it was so dark. "I had to get a new ticket, and it cost me a fortune to get home."[110] London's nocturnal house was so dark that it was impossible to see the animals. The Kingdoms of the Night seeks to maintain a level of darkness that accommodates the public and allows guests to see the animals while still immersing them in the night. The zoo encourages animals to sleep at night by turning the lights on to simulate day and turns them off during the day so the animals will be awake for visitors.

The Kingdoms of the Night Experience

It takes most visitors a few minutes to transition from the light of the Sonoran Desert to the canyon that they enter when they go downstairs to the Kingdoms of the Night. The exhibit and mechanical space cover an acre. The cave tunnel, featuring naked mole rats, fossa and cacomistle, leads to an African diorama where people can stand inside a baobab tree to see the transition from dusk to evening. Here they can see how animals such as aardvarks, springhaas and greater bush babies interact.

Next comes the wet cave, an intense experience of walking through stalagmites and 2,400 dripping stalactites into a sixteen-foot-deep pit of water area that houses blind cave fish. The thousands of fruit bats that fly around the large bat cave might remind guests of visiting a haunted house on Halloween. Omaha's Henry Doorly Zoo and Aquarium is one of just six American zoos to feature a Japanese giant salamander in the wet cave.

Visitors travel next to a fragrant Australian eucalyptus forest, wandering past parma wallabies. There's a stream full of crocodiles, turtles and fish. Still more bats live in a dry bat cave illuminated by light from a crack in the seventy-foot-high ceiling of the mountain.

Strolling on a boardwalk through the world's largest indoor swamp completes the spooky trip through the nocturnal world. It's every sinister creepy swamp movie come to life. There's an old wooden trapper's cabin, a beaver lodge, cypress trees and thirty-eight swamp animal species in a barrier-free environment. Nine American alligators live in the swamp, separated from the public by a waist-high transparent wall.[111] Sounds of alligators and frogs are piped in to remind guests that "when we take away one sense, we focus on another, hearing," said Simmons.[112]

Public Reaction

Like the Lied Jungle and the Scott Aquarium, Omaha zoo goers were excited to visit the Desert Dome after it opened on March 27, 2002, and the Kingdoms of the Night exhibit when it opened the following April. Some 68,800 people toured the Desert Dome during its first week, which at the time was the highest attendance for a zoo exhibit's opening week. Simmons told the *Omaha World-Herald* that crowds exceeded expectations.[113] It took several months for the lines into the building to shorten and for the zoo to solve some minor problems, such as controlling the exhibit's prairie dogs.[114] Public enthusiasm for the Desert Dome led to the zoo's second-most successful membership drive, with total sales of 67,433 family memberships, about 6,000 less than when the Scott Kingdom of the Seas Aquarium opened.[115]

When the Kingdoms of the Night exhibit opened, visitors waited in line to be among the first to see it. In the first few hours, more than 1,000 people toured the exhibit. Visitors praised the variety of animals, the swamp and the realism of the experience. Although they didn't complain about bumping into one another in the dark, zoo officials promised to adjust light levels.[116] Family membership sales of 62,332 that year exceeded the 60,000 goal but were down about 7.5 percent from the year before.[117]

Creating Hubbard Gorilla Valley and Hubbard Orangutan Forest

For years, Simmons maintained a public wish list of exhibits he hoped to construct, and most are now popular exhibits. However, he failed to bring giant pandas from China to Omaha and acknowledged that "in retrospect, I'm happy we didn't get them."[118] Not only are pandas extremely expensive to care for, but zoos must also contribute to conservation projects in China and they sleep a lot. In the hope of getting pandas, the zoo constructed a second floor for its elevator tower with a lobby area and a long hallway where it now holds and protects from extinction the "largest number of frogs and other amphibians of any zoo in North America" as part of its important amphibian conservation project. Many frogs that have been bred at the zoo have been released back into the wild.[119]

Construction of this area also was integrated with a massive expansion of the zoo's long-standing popular gorilla and orangutan displays: the $14.5

The Hubbard Gorilla Valley under construction. *Courtesy of Dr. Lee Simmons.*

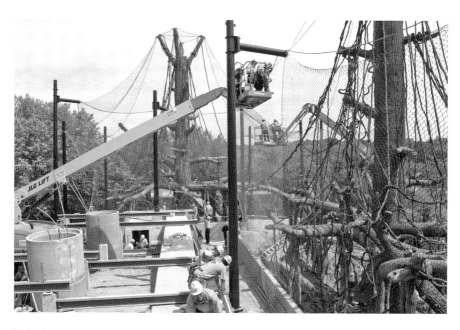

This photo shows the Hubbard Orangutan Forest under construction. *Courtesy of Dr. Lee Simmons.*

million Hubbard Gorilla Valley and $8.5 million Hubbard Orangutan Forest. Simmons noted that the Henry Doorly Zoo was building new facilities for gorillas and orangutans when he was hired and later had renovated them into the Owen Gorilla House and the Owen Orangutan House. However, both needed remodeling, and the zoo wanted to expand both its collections of the two species and its primate reproductive research.

Planning for both the gorilla and orangutan projects began while the zoo was finishing construction of the Desert Dome and the Kingdoms of the Night. Members of the family of the late Dr. Theodore Hubbard, an Omaha cardiologist, were the primary funders of both projects. His daughter, Dr. Anne Hubbard, had accompanied Lee and Marie Simmons on a trip to East Africa. When Mrs. Hubbard and Simmons discussed which "wish list" project might best honor Dr. Hubbard, she suggested funding the butterfly house, but gorillas topped Simmons's list. "We talked for forty-five or fifty minutes and agreed that the gorillas fit Dr. Hubbard's personality better than the butterflies," said Simmons.[120] The Hubbards also helped pay for the elevator tower project and for constructing a wing expanding the Grewcock Center for Conservation and Research.

Hubbard Gorilla Valley

Hubbard Gorilla Valley, a three-acre site, opened in 2004 and expanded the Henry Doorly Zoo's prominence in gorilla conservation and research work. In 1995, the word's first test tube gorilla was born at the Cincinnati Zoo with sperm and scientific help from Henry Doorly Zoo, which operates the world's largest gorilla sperm bank. Today's Gorilla Valley building is six times larger than its predecessor. The main habitat area promotes gorilla-human interaction with eight large windows, a five-foot acrylic hemisphere and a twenty-five-foot-long S-shaped gorilla window. Twenty-four-foot trees under skylights support a tangle of vines that gorillas enjoy swinging from. The floor is heated with varying temperatures in different areas so gorillas can pick a comfortable area to sit.

Outside, the Gorilla Valley has expanded habitat ten times greater than its predecessor. A 16-foot-wide by 12-foot-tall window-lined tunnel some 520 feet long allows visitors to watch gorillas and other animals roaming freely in their habitats. Other animals include monkeys, yellow-backed duiker and ground hornbills.[121]

Above: A gorilla relaxes in the Hubbard Gorilla Valley's indoor exhibit. *Photo by Mary Plambeck Cook.*

Right: Fall is pumpkin time for this gorilla in the Hubbard Gorilla Valley's indoor display. *Photo by Mary Plambeck Cook.*

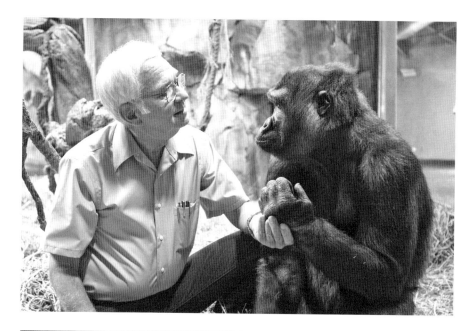

Ever the veterinarian, Dr. Lee Simmons enjoyed working with animals like these gorillas. *Courtesy of Dr. Lee Simmons.*

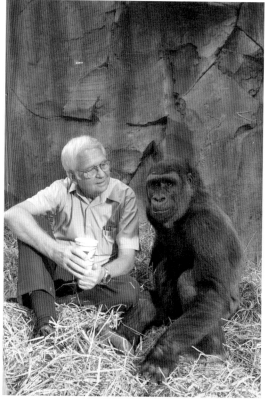

Hubbard Orangutan Forest

A playful orangutan enjoys the Hubbard Orangutan Forest. *Photo by Mary Plambeck Cook.*

The $8.5 million adjacent Hubbard Orangutan Forest, which opened in 2005, features an elevated platform just north of the elevator building, where visitors can watch orangutans swinging through the trees. They also can view them from inside the elevator building. The outdoor forest covers 3,763 square feet, and the indoor forest habitat is 32 feet tall and covers 3,127 square feet. The forest also displays gibbons. A 21,211-square-foot stainless-steel net covers the outdoor habitats.

During winter, all orangutans and monkeys are on display in massive indoor habitat that reaches a height of thirty-two feet under skylights. At night they live in bedrooms hidden from the public.[122]

BERNIECE GREWCOCK BUTTERFLY AND INSECT PAVILION

In 2008, the Henry Doorly Zoo finally opened its long-sought butterfly house, a fourteen-thousand-foot immersion exhibit located near the Scott Aquarium. From the sky, the building resembles a butterfly, and there is a colored glass sculpture of butterflies outside it, as well as a display of bronze butterflies with names of donors.

Guarded doors at the entrance and exit ensure that no butterflies are clinging to departing visitors. The 2,450-square-foot conservatory features 10-foot-high glass side walls with lush plants, trees and water to simulate the natural habitat of tropical butterflies. The climate is hot and muggy. Visitors walk slowly down the paths to spot the various species of butterflies and hummingbirds flying freely around the exhibit.

The pavilion also includes displays of ants, spiders, scorpions, walking sticks, mantids, centipedes, roaches, beetles and other insects, as well as a room where the public can view butterflies hatching.[123]

Simmons said that many people don't realize that butterfly houses like this can help conserve the rainforests by giving forest residents an economic

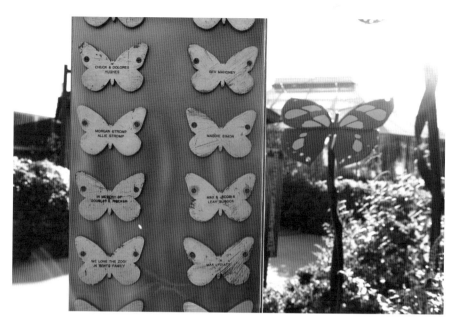

Donors to the Berniece Grewcock Butterfly and Insect Pavilion are recognized by name on butterfly sculptures outside the entrance. *Photo by Mary Plambeck Cook.*

This photo shows the Berniece Grewcock Butterfly and Insect Pavilion under construction. *Courtesy of Dr. Lee Simmons.*

incentive to preserve their habitats. "Butterflies lay their eggs in the wild," said Simmons.[124] Rainforest residents in South America, Africa and Southeast Asia discover that if they preserve the trees where butterflies lay their eggs, they can make money regularly by selling the cocoons to butterfly houses like the Henry Doorly Zoo's. Butterflies could become an annual cash crop, while wood from trees that are chopped down can only be sold once. "This is a hugely positive conservation incentive."[125] Since butterflies live only a short time, zoos must constantly restock their supplies.

OTHER IMPROVEMENTS

As the decade drew to a close, the zoo continued to expand its research and conservation work with many species, especially after the three-story Hubbard Wing expansion of the Grewcock Center for Conservation and Research opened in 2006. Structurally, this was a duplicate of the original Grewcock Center. It includes an upper floor where student researchers can live while working on research projects at the zoo. The zoo also employs a cadre of full-time researchers and receives grants from foundations and philanthropists to underwrite their work. Many projects combine lab research with hands-on service and education in countries around the world, best illustrated by the final major project of Simmons's years as zoo director—Expedition Madagascar—which was planned during this period and opened in 2010.

TRANSITION TO A NEW DIRECTOR

In 2008, shortly before he was to lead a safari to Africa, Dr. Lee Simmons, then seventy, told his doctor during a routine physical exam that he'd had some shortness of breath. The doctor ordered tests that showed Simmons had a heart valve problem that would require open heart surgery, the sooner the better. However, Simmons told his cardiologist that the operation would have to wait until he returned from Africa, which it did.

When Simmons told the zoo's board about the surgery, it spurred members into starting succession planning.[126]

For decades, Simmons had managed the zoo, developed and designed exhibits, raised funds and become a world leader in international animal conservation programs. If something happened to him, what would the zoo do? Eventually, the zoo began a quiet national search for the next director, with Simmons serving on the committee.

On January 14, 2009, Simmons announced his pending retirement as zoo director and his move to zoo foundation chairman, saying, "This seemed like the time to do it."[127] During Simmons's years as director, attendance rose from about 270,000 to about 1.4 million, and he developed about $160 million in world-class exhibits. Zoo board chairman Walter Scott saluted the transformation, saying, "Everything you see out there is because of what Lee has done. I think Lee has done an outstanding job."[128] Simmons, who had already received numerous awards, received even more, including becoming King of Aksarben, one of Omaha's top civic honors.

Left: Dr. Simmons shows off a bobcat. *Courtesy of Dr. Lee Simmons.*

Right: Executive director Dennis Pate has led Omaha's Henry Doorly Zoo and Aquarium into a new era of habitat exhibits while emphasizing wildlife conservation and research work. *Courtesy of Omaha's Henry Doorly Zoo and Aquarium.*

A day later, the zoo announced that it had hired Dennis Pate, director of the Jacksonville Zoo and Gardens, as the new executive director. Scott said, "We were looking for someone who can make things happen. We have a great opportunity to build a bigger and better zoo."[129]

Pate, son of a much-traveled military family, said he was attracted to Omaha's Henry Doorly Zoo and Aquarium primarily because it had created outstanding programs in animal conservation and research in addition to iconic exhibits and because it had great community and financial support. "Doc [Simmons] is the reason I'm here. I was attracted to Omaha because it was heavily involved in wildlife conservation. Here we have made a significant commitment to build on."[130]

Pate began his zoo career in 1974 as a summer keeper at Chicago's Lincoln Park Zoo. Since he was a child, he had wanted a job working with animals. He drove a cab and worked construction after graduating with a degree in animal science from the University of Illinois until he found one. Eventually, he became a full-time keeper and then assistant curator at Lincoln Park Zoo, working with mammals and birds. In 1987, he became general curator of the Oregon Zoo. He returned to Chicago ten years later as the senior vice president at Lincoln Park Zoo. In 2001,

he was named director of the Jacksonville Zoo and Gardens and led it until moving to Omaha. In Jacksonville, he raised $37 million, completed a master plan for the zoo and gardens, established a botanical garden, completed an award-winning South American exhibit, designed and completed a children's Play Park, including a splash ground that featured local marine mammals, and opened a Komodo dragon exhibit.[131]

Leaders of national zoo groups praised Pate as "thoughtful, analytical and fair" and described him as a calm, energetic "go-getter" manager with great people skills.[132]

When Pate became director in mid-March, he took over completion of two major projects: the acquisition of the Rosenblatt Stadium adjacent to the zoo and completion of the Expedition Madagascar exhibit. He completed a master plan in 2010 for the zoo that called for a new entry experience. He also began enhancing the guest experiences through separating ticketing from admissions, expanding parking, building new pedestrian-scale paths and making other infrastructure changes, such as upgrading technology and graphics and creating a new front entrance. "When you walk through our front gates, we want you to feel you are in a different place."[133] Most importantly, the ten-year master plan features exhibits that emphasize "whole habitats working together."

"I'm a planner. I love the planning process," said Pate.[134] The first project completed with the front entrance improvements was a renovation of the aquarium and the addition of an eleven-thousand-square-foot education and conference center. Two major projects built under the plan—the African Grasslands and the Alaskan Adventure—opened in 2016.

Pate said that he wants exhibits to "engage guests with animal conservation stories and authentic habitats. The lion exhibit [in the African Grasslands exhibit] may be the best example of that." Guests can see lions roaming in an outdoor area that resembles the African savanna instead of being housed in a building. "What Doc did inside with exhibits like the jungle, I am now doing outside in building the grasslands. We want to get people to love animals from an early age. We want animals to be part of our lives and culture. We want to use the zoo to encourage people to care about animals in the wild."[135]

The zoo also educates guests about the lives of animals and animal conservation through photos, digital graphics and videos in exhibit areas. As people visit Hubbard Gorilla Valley, for example, they walk down hallways full of photos and signs that teach them about threats to gorillas in the wild and how the zoo's conservation and assisted reproduction

research seek to preserve the species. "Our focus is on animal welfare and using exhibits to educate guests about animal conservation," Pate said.[136]

Meanwhile Pate also focused on the Rosenblatt and Madagascar projects.

(ROSENBLATT) INFIELD AT THE ZOO

For decades, Omaha's Henry Doorly Zoo and Aquarium and Rosenblatt Stadium, home of the College World Series and Omaha's succession of triple-A teams, were friendly neighbors. However, as zoo attendance rose and Rosenblatt's seating capacity was expanded, parking became an increasing problem for both, especially during the College World Series, when fans spilled into zoo parking. Many Omahans avoided the zoo during the tournament because of parking problems.[137]

Parking issues were among the reasons that the NCAA threatened to move the College World Series unless Omaha built a larger stadium. Omaha built T.D. Ameritrade Park downtown in return for a fifty-year CWS contract. In 2008, the city sold Rosenblatt to the zoo foundation for the $12 million that it owed for past stadium improvements. And that

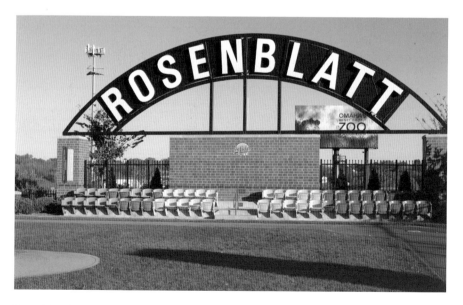

Rosenblatt Stadium's iconic sign is featured at today's Infield at the Zoo. *Photo by Mary Plambeck Cook.*

The scoreboard from Rosenblatt Stadium now carries messages about the zoo and is visible to cars on Interstate 80. *Photo by Mary Plambeck Cook.*

Infield at the Zoo preserves an important part of Omaha's baseball heritage, with home plate in its traditional location. *Photo by Mary Plambeck Cook.*

was just the start. It cost the zoo about $2 million to demolish the stadium and $39 million for other improvements, including a new front gate. But the zoo gained an additional thirty-five acres for more parking.[138]

South Omaha residents and members of Mayor Johnny Rosenblatt's family strongly urged preserving a few key elements of the stadium, possibly home plate and the batter's box area.[139] In response, the zoo created Infield at the Zoo on the site of Rosenblatt's infield.

"The zoo and the stadium have grown up together," said Pate when he announced the plan. "We will remember that with this little oasis park."[140] South Omaha City councilman Gary Gernandt called the idea a "jaw dropper" and thanked the zoo.[141] An *Omaha World-Herald* editorial said, "The plan incorporates real mementos of the stadium. It's not fancy, just an honest and elegant tribute to an Omaha sporting venue with a long and honored history."[142]

Today Infield at the Zoo sits in the middle of zoo parking lots where the stadium used to be. Home plate is in its historic location, and the foul poles have been preserved in their original places. The infield is the size of a little league field, with sixty feet between bases instead of ninety, and the iconic ROSENBLATT arched sign has been moved from its former location on the scoreboard to the infield. Original red, yellow and blue seats have been reused, and the old scoreboard is now a sign board for the zoo. Signs in the infield recognize the stadium's history and some of the players who played there.[143] The old media tower has been installed in Wildlife Safari Park, where it is called Crane Meadows Viewing Tower.

Pate says it is heartwarming to see kids running the historic base paths, especially during the College World Series. "The zoo was part of the College World Series. The Desert Dome was part of the ballgames. We did this for the neighborhood and baseball fans."[144]

EXPEDITION MADAGASCAR

A decade before Omaha's Henry Doorly Zoo and Aquarium opened the Expedition Madagascar exhibit, it created its award-winning Madagascar Biodiversity Partnership under the leadership of Dr. Edward Louis Jr., director of conservation genetics, to promote wildlife conservation in this important island nation in the Indian Ocean. Work has included

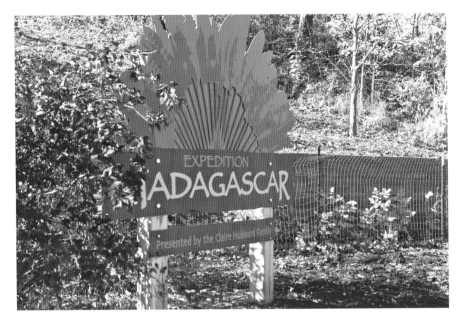

Expedition Madagascar showcases animals from that island nation and educates visitors about the zoo's conservation and research programs there. *Photo by Mary Plambeck Cook.*

identifying twenty-three new lemur species, with more new species in the pipeline, reintroducing two species of lemurs in an area where hunting had wiped them out, starting a reforestation project to reconnect stretches of lemur habitat and launching efforts to replace open cook fires with more efficient stoves. Plant conservation is also part of the zoo's program.[145]

This work is showcased in the $10.5 million Expedition Madagascar exhibit, which opened in 2010 and focuses heavily on the biodiversity project. "It's the first exhibit that's really established a very strong link between the conservation work we do and the animals we exhibit," said Pate. "Going forward, you're going to see more of that."[146]

Simmons called it "the best Madagascar exhibit in North America."[147]

The vast majority of Madagascar's plants and animals can be found nowhere else. However, logging, mining, clearing land for farming and poaching threaten the island's plants and animals because the people are poor.[148]

Expedition Madagascar introduces guests to the island's ecosystem, people and animals along with telling inspiring stories of the zoo's efforts

to save the island's plants and animals. A video at the entrance, for example, showcases University of Nebraska at Omaha students volunteering in conservation programs. The fourteen indoor exhibits house a wide array of species in addition to lemurs, including fish, reptiles, amphibians, small mammals and birds. An outdoor lemur walkway features lemurs in a natural setting.[149]

Simmons said that the biodiversity project employs many local residents to extract fruit seeds from lemur droppings and then plant the seeds to grow new trees. Such seeds have an 80 percent germination rate versus 10 percent from those that fall from trees. The project has already planted more 900,000 trees in Madagascar. "We employ a lot of local labor to plant trees. We have a big economic impact."[150]

OTHER ADDITIONS

Other additions to the zoo since 2010 include:

- Opening the Omaha Steaks Grill and Patio in 2011
- Updating the Red Barn Park area with the new Prehistoric Play Park and Fossil Dig site in 2012
- A new first aid station supported by nursing staff from Children's Hospital
- A new guest services area to handle memberships, lost and found, security and visitor questions.
- New restrooms just outside the front entrance
- A new stingray fountain and sculpture near the aquarium
- A new 5,600-square-foot main gift shop and stroller rental area, adding more than one thousand parking stalls and renovating Durham TreeTops Restaurant in 2013
- Opening Stingray Beach and Camel Rides, both located by Sue's Carousel in 2014
- The entire entry was the first project constructed under the new master plan. As noted elsewhere, the Scott Kingdom of the Seas Aquarium has undergone major renovations, and a new roof is being installed on the Lied Jungle. Most importantly, the African Grasslands exhibit, the first major exhibit constructed under the master plan and the beginning

of construction of other new exhibits, showed the exciting future ahead for Omaha's Henry Doorly Zoo and Aquarium. Meanwhile, researchers at the zoo continued their important work in animal and plant conservation.

PRESERVING ENDANGERED SPECIES

For years, zoos have been popular places for people to enjoy displays of exotic animals and learn about their natural history, but by the 1970s, they were becoming key players in scientific efforts to preserve endangered species from extinction. They began to collaborate with one another and with researchers from universities and scientific groups, such as the Smithsonian Institution, in studying assisted reproduction of rare animals in captivity.

"The zoo world had evolved from selling animals to other zoos to breeding loan exchanges and sharing the offspring," said Dr. Lee Simmons. "Sometimes an offspring might be sent to yet a third or fourth zoo with the goal of preserving the captive population of that endangered species. The actual sale of animals for money had virtually ceased between accredited zoos."[151] The Henry Doorly Zoo became a significant participant in these programs to propagate a variety of animals and to manage them for the good of the species. Eventually, it built its own Center for Conservation Research, hired a twenty-member research staff and branched out into numerous fields related to protecting rare and endangered plants and animals.

ROOTS OF THE CONSERVATION RESEARCH PROGRAM

Ulysses Seal, a medical researcher with the Veterans Administration in the Twin Cities, launched the zoo research revolution when he got interested in wildlife in the 1970s, according to Dr. Douglas Armstrong, director of animal health at Omaha's Henry Doorly Zoo and Aquarium. When Seal asked the zoo veterinarians' organization for basic information about such things as normal animal blood values and discovered that the data did not exist, he enlisted Simmons and others to help collect the information. Because Simmons got heavily involved in such studies, he became an early leader of zoo research work.[152]

By the late 1980s, Simmons had developed a vision of a comprehensive conservation research program that laid the groundwork for today's extensive programs in fields such as genetics, assisted reproduction, nutrition and endangered plants and protecting biodiversity. However, it took years to implement this vision. When Armstrong joined the zoo in 1985, he was its only veterinarian besides Simmons, and he filled the role of researcher.[153]

EARLY BREEDING PROGRAMS

The zoo's breeding efforts began with polar bears and grizzly bears since it had males and females that could be mated "the old-fashioned way," said Simmons.[154] Success in breeding bears led to work with other species, including big cats, black-footed ferrets and gaur. Its gorilla breeding exchanges with other zoos made headlines. The Henry Doorly Zoo and Simmons also consulted with the Moscow Zoo on preservation programs, giving the zoo prestige and building its international reputation. It also began building facilities for research work, beginning with a Primate Research Building in collaboration with the University of Nebraska Medical Center in 1973. That building is now gone.

STUDYING BIG CATS

In the 1970s, the zoo wanted to undertake research to help breed endangered species in captivity. However, it lacked the sophisticated laboratory facilities required for analyzing data and publishing findings and couldn't afford to hire its own scientific staff. The best solution seemed to be to collaborate with partners who had such staff and facilities but lacked the animal populations required for studies. The Henry Doorly Zoo's large populations of lions, tigers, jaguars and other large cats made it an attractive research site for studies of reproduction in various species. In addition, because the Henry Doorly Zoo was not affiliated with a university or government, it was able to work quickly and effectively without seeking permission from layers of academic or governmental bureaucracy. In a win-win for everyone, Simmons and the Henry Doorly Zoo invited scientists from the Smithsonian Institute, the National Zoo, the University of Minnesota and other prestigious groups to come to Omaha to conduct field research on big cat reproduction and publish the findings in academic journals. Thus, an innovative and scientifically important program began.

The researchers came to Omaha twice a year to collect data from the zoo's substantial collections of rare animals. Then they returned to their labs to analyze their findings. "They had to find their own way here. They stayed at our house, sleeping in the kids' rooms, on the couches and floors, and Marie [Simmons's wife] fixed breakfast and dinner. They would work for a week or ten days then come back in six months to do it again."[155] The result was cutting-edge work in such fields as artificial insemination, in vitro (test tube) fertilization and genetics that helped build the Doorly Zoo's national reputation.

SAVING BLACK-FOOTED FERRETS AND PROPAGATING GAURS

Big cats weren't the only beneficiaries of the Henry Doorly Zoo's efforts to protect endangered species. In the 1980s, Wyoming Fish and Game found a small group of black-footed ferrets in Wyoming, a species that had twice been declared extinct. It captured 18 ferrets that had survived an outbreak of distemper and brought them first to a lab in Wyoming.

Several of them reproduced and came to the Henry Doorly Zoo and two other zoos to expand their breeding potential. In 1988, the Henry Doorly Zoo received 8 ferrets and succeeded in being the first zoo to breed them. Over a ten-year period, the zoo produced 305 kits, and they were released back into the wild or sent to other zoos. Today, there are about 300 in the wild. In 1989, the zoo constructed the black-footed ferret building, and in 1993, it received a prestigious AAZPA Conservation Award for the black-footed ferret management program.

Another award-winning effort involved breeding gaur—the largest wild cattle, sometimes called Indian bison—because the zoo had long had a large population of these animals. International animal conservation groups have classified the species as vulnerable. In 1989, the zoo received the prestigious AAZPA Bean Award for its long-term gaur propagation efforts. In 1993, the world's first artificially inseminated gaur calf was born at the zoo.[156]

GORILLA TWINS AND A TEST TUBE GORILLA

During the 1970s and '80s, the Henry Doorly Zoo also became involved in loaning and borrowing animals specifically for breeding purposes. In 1983, Brigitte, a gorilla owned by the Henry Doorly Zoo, delighted animal lovers in Omaha and Columbus, Ohio, by giving birth to a rare set of twins while on breeding loan to the Columbus Zoo.

"We had a proven female but no male," said Simmons. "We sent Brigitte to Columbus with the intent that we would share every other baby, but she double-crossed us and had a very rare set of twins."[157]

The twins caused the two zoos a bit of a dilemma. Normally, one zoo gets the first offspring and the other the second. However, that would have involved separating the twins—something neither zoo wished to do. Since both zoos wanted to keep the twins together, they moved them back and forth between Columbus and Omaha, drawing great public attention in both cities. Ultimately, the twins, both males, stayed in Omaha until they became teenagers and started fighting with each other. In effect, they "separated themselves."

Zoo researchers began to employ new scientific reproductive methods in their efforts to breed gorillas in captivity. In 1995, the zoo participated in the propagation of the world's first test tube gorilla, Timu, who was

born in the Cincinnati Zoo. In 1996, she moved to the Henry Doorly Zoo, where she bred and produced several offspring.

Building International Ties

As the Henry Doorly Zoo's reputation for work in animal conservation and breeding grew, Simmons was invited to consult with international zoos to help them with their programs. Starting in the late 1970s, he built a significant relationship with the Moscow Zoo.

"In 1978, we went to Russia on a scientific exchange program on capturing animals," he said. "I had invented a long dart gun and darts to immobilize animals in order to treat them. The Soviets invited me as part of a three-man team to do a scientific study."[158] The study took place in the field in chilly December. Simmons formed a relationship with the director of the Moscow Zoo that resulted in two other trips to Russia to do research. In addition, Russians have come to Omaha seven or eight times for collaboration and training.

Research Facilities

In 1996, the Henry Doorly Zoo opened the $2.4 million Bill and Berniece Grewcock Center for Conservation and Research to house its growing staff of researchers. Ten years later, it opened the Hubbard Research wing, a $6 million addition to the Grewcock Center that more than doubled its size. Today, the CCR houses the zoo's twenty staff scientists, who study everything from propagating rare species of orchids to how diets can be modified to prevent kidney stones in aging animals. The walls of the two wings are lined with the numerous publications, posters and plaques heralding major accomplishments by the zoo's scientists and veterinarians. The CCR includes a dormitory that houses visiting researchers and students doing research studies at the zoo.

TODAY'S MAJOR RESEARCH PROGRAMS

Omaha's Henry Doorly Zoo and Aquarium's research programs focus on five major fields: molecular genetics, reproductive science, comparative nutrition, plant micro propagation and conservation medicine. Numerous pages on the zoo's website provide extensive information on work to conserve various species of plants and animals. In the past ten years, zoo scientists have published dozens of research papers.

Some programs, such as the biodiversity program in Madagascar, have received extensive public attention and national awards, while others are less well known, such as the zoo's studies of plant propagation that help conserve the habitats that wildlife and people depend on for survival.

PROPAGATING EXOTIC PLANTS

From the hallway in the CCR, Margaret From's plant laboratory looks a bit like a cross between a lab and a greenhouse filled with the many specimens she is studying. From, who heads the plant propagation program, is the zoo's expert on orchids, including those found on the prairies. However, Doug Armstrong said her most famous feat was bringing Bermuda ferns back from extinction.

"Bermuda ferns were declared extinct, but the British had built a huge greenhouse there, and in 2004, workers discovered several of those ferns in their greenhouse that had not (previously) been identified. They tried to propagate them, collected spores and sent the spores to Marge," he said.[159]

While From worked with the spores to revive the species, a hurricane destroyed the greenhouse in Bermuda and with that the ferns. However, From succeeded in using the spores to grow Bermuda ferns in Omaha, thus bringing the species back to life. She then sent hundreds of the ferns back to the island.

Armstrong also noted that From's work with orchids that grow wild in Nebraska has helped develop techniques to propagate the tropical orchids that are important in helping preserve endangered species in rainforest regions.

Experts estimate that for every plant species that goes extinct, ten to thirty animal, insect or microbe species disappear. Animals and humans cannot survive without the plants that provide their food, shelter, medicine and cover.[160]

OTHER MAJOR RESEARCH

Omaha's Henry Doorly Zoo and Aquarium is a leader in many conservation fields, including participating in SECORE (Sexual Coral Reproduction) out of its Scott Aquarium, the most important coral reef conservation in zoos and public aquariums worldwide. The Reproductive Science Department's important Tiger Project focuses on all aspects of assisted reproductive technology, including artificial insemination, semen freezing, in vitro embryo production and much more. The zoo built the nation's first major amphibian conservation program and collaborates with other zoos and conservation organizations in the Amphibian Conservation Initiative. The initiative works in breeding programs for amphibian species that are in danger of extinction.[161] The Nutrition Research Program contributed to important advances in exotic cat, giraffe and amphibian nutrition—to name just a few more examples of the work zoo scientists and veterinarians are doing.

Some zoo research focuses on the health problems of its own animals. For example, zoo veterinarians give male gorillas regular echocardiograms because heart disease is the major cause of death of gorillas in captivity. "We don't know what causes their heart disease and we don't know if gorillas in the wild get heart disease since we can't do echocardiograms on them," said Armstrong.[162]

The zoo also is involved in collaborative field research on the threats to elephants, giraffes and rhinos in South Africa and Kenya. The zoo's African Grasslands Exhibit contains numerous signs that educate guests about conservation efforts to counter threats to the animals they are seeing.

THE FUTURE OF RESEARCH

Omaha's Henry Doorly Zoo and Aquarium will continue all of its research programs because "the need for conservation is only increasing," said Armstrong.[163] Many of the threats to animals are man-made: poaching, deforestation in tropical regions, global warming and spread of diseases between animals and people.

"We have more interaction between wildlife, domestic animals and people," said Armstrong.[164] For example, fruit bats in Africa carry Ebola to more people because society is more mobile. People spread a disease from

place to place as they travel, whereas earlier outbreaks might have been limited to isolated regions.

Growing human populations have taken over increasing animal habitats, and more and more animals like giraffes are now killed for their meat. Poachers use devices such as drones, GPS and helicopters to find and kill rhinos that conservationists are protecting behind electrified fences because rhino horn is worth more than gold.

Armstrong said that research also teaches zoos and conservationists about mistakes they have made in fields such as reproduction. For example, during the 1980s and '90s zoos tried to manage reproduction in captive animals by using birth control medicines to delay it. However, "now we have animals that can't or won't breed."[165] As a result, zoos are now breeding animals while they are young.

Executive Director Dennis Pate says the zoo's dedication to research and conservation helped bring him to Omaha, and continuing such work is a top priority.

"In addition to the work done by our own scientists, the zoo contributes to projects that help conserve animals in the wild. The zoo has increased its support annually to field conservation projects and has provided funds for over fifty projects in the last few years. It also has provided emergency funding for okapi and orang projects that were decimated by civil war or catastrophic fires."[166]

CONSERVATION AWARDS

Significant Conservation-Related Awards and Achievements

- 2016 Salt Creek Tiger Beetle Conservation Award, presented by the Association of Zoos and Aquariums.
- 2016 Friend of the Environment Award, Business/ Organization Winner, presented by Earth Day Omaha.
- 2015 Tributary Award from the Natural Resources District for our work with the Salt Creek Tiger Beetle.
- 2013 Omaha's Henry Doorly Zoo and Aquarium's Associate Scientist of Comparative Nutrition, Cheryl L. Morris, is named AZA Felid TAG's vice chair.

- 2013 Omaha's Henry Doorly Zoo and Aquarium's Nutrition Department publishes research in *Journal of Animal Science* and *Zoo Biology*.
- 2012 Omaha's Henry Doorly Zoo and Aquarium's Nutrition Department publishes research in *Journal of Animal Science*.
- 2011 Omaha's Henry Doorly Zoo Molecular Genetics Department collaborative research project looking at the genome of the aye-aye results appears on the cover of the *Genome Biology and Evolution* journal.
- 2011 Omaha's Henry Doorly Zoo Molecular Genetics Department publishes in *Oryx, American Journal of Physical Anthropology* and *Zootaxa*.
- 2011 Director of plant conservation at Omaha Henry Doorly Zoo's Lab for Rare and Endangered Plants, Margaret M. From, publishes the discovery of a new orchid species from Madagascar in the journal *Phelsuma*.
- 2011 Omaha's Henry Doorly Zoo's Nutrition Department publishes research in *Zoo Biology, British Journal of Nutrition* and *Journal of Animal Science*.
- 2011 Margaret From, director of plant conservation at Omaha's Henry Doorly Zoo, is appointed to the Species Survival Commission of the International Union for the Conservation of Nature (IUCN).
- 2010 Omaha's Henry Doorly Zoo's director of comparative nutrition, Cheryl L. Morris, publishes two case studies in the book titled *Small Animal Clinical Nutrition*.
- 2010 Omaha's Henry Doorly Zoo Rare Plant Research Lab has three reintroduction case studies published by the International Union for the Conservation of Nature in the book titled *Global Re-Introduction Perspectives: 2010*.
- 2010 Omaha's Henry Doorly Zoo's Nutrition Department publishes research in *Zoo Biology* and *Journal of Dairy Science*.
- 2010 Omaha's Henry Doorly Zoo Molecular Genetics Department and the Madagascar Biodiversity Partnership win the 2010 AZA International Conservation Award.
- 2010 The third addition of the book *Lemurs of Madagascar* is released. Omaha's Henry Doorly Zoo director of molecular genetics, Dr. Edward E. Louis Jr., is coauthor of this book.

- Dr. Doug Armstrong is made vice president of the American Association of Zoo Veterinarians.
- 2010 Omaha's Henry Doorly Zoo Molecular Genetics Department researchers publish the first complete mitochondrial genome of a sportive lemur.
- 2010 Omaha's Henry Doorly Zoo Molecular Genetics Department publishes "Microsatellite Analyses Provide the First Evidence of Sex-Biased Dispersal in Tortoises" in the *Journal of Heredity*.
- 2010 Artificially inseminated and produced over 1,400 critically endangered Mississippi Gopher Frog tadpoles using cooled shipped semen from the Memphis Zoo, potentially increasing the world population twelve times.
- 2010 Reproductive scientist Jonathan Aaltonen is appointed treasurer of the International Society of Wildlife Endocrinology (ISWE).
- 2009 Omaha's Henry Doorly Zoo Molecular Genetics Department has six publications in the journal *Lemur News*, three in *Conservation Genetics*, one in the Texas Tech University Museum *Occasional Papers* and one in *IUCN's Primates in Peril: The World's 25 Most Endangered Primates 2008–2010*.
- 2009 The Lab for Rare and Endangered Plants at Omaha's Henry Doorly Zoo publishes two manuscripts: "Aeranthes: Flowers in the Air" and "Special Report/Saving Madagascar's Orchids," in the journal of the American Orchid Society magazine, *Orchids*.
- 2009 The director of Plant Conservation at Omaha's Henry Doorly Zoo, Margaret M. From, is appointed a member of the Nebraska Department of Roads' Environmental, Hydraulics and Roadways Focus Group Council.
- 2008 Garden Clubs of America Award given to Margaret From for her contributions to plant science.
- 2008 Grant awarded from the Association of Zoological Horticulture for Cryopreservation and Recovery of Fungal Symbionts Associated with Nebraska Population of the Western Prairie Fringed Orchid.
- 2008 Omaha's Henry Doorly Zoo Molecular Genetics Department publishes a paper in the journal *Lemur News*, one in the *American Journal of Primatology*, one in *Science*, three in

Conservation Genetics, one in the Texas Tech University Museum Special Publications and one in *Primate Conservation*.

- 2008 Omaha's Henry Doorly Zoo Molecular Genetics Department and Madagascar Biodiversity Partnership sends fifteen thousand conservation-based activity books to primary schools throughout Madagascar.
- 2008 The Madagascar Biodiversity Partnership builds the Kianjavato Ahmanson Field Station in southeastern Madagascar.
- 2008 Omaha's Henry Doorly Zoo Molecular Genetics Department establishes its fuel-efficient "Rocket Stove" project, in which they work with a North High School team to determine the greatest way to construct the stoves.
- 2007 Omaha's Henry Doorly Zoo Molecular Genetics Department publishes a paper in Texas Tech University Museum Special Publications, two in *Molecular Ecology Notes*, one in *Journal of Zoo and Wildlife Medicine* and one in *Conservation Genetics*.
- 2007 Reproductive physiologist Dr. Naida Loskutoff is named the International Embryo Transfer Society's (IETS) new president—the first woman and the only zoo-based researcher elected president.
- 2007 World's first snake species model (corn snakes) to be produced by artificial insemination using fresh or chilled snake semen collected non-invasively.
- 2007 Grant awarded by the Institute of Museum and Library Services for Cryopreservation of the Imperiled Madagascar Plant Collection for Long Term Conservation.
- 2006 Friends of the Boyer Chute research grant awarded for native lily propagation and field restoration.
- 2006 Omaha's Henry Doorly Zoo Molecular Genetics Department publishes two articles in the Texas Tech University Museum Special Publications, seven in *Lemur News*, three in *Molecular Ecology Notes*, two in *Conservation Genetics* and one in the *International Journal of Primatology*.
- 2006 Dr. Edward E. Louis is the coauthor of *Conservation International Tropical Field Guide Series: Lemurs of Madagascar*, 2nd Edition; *Lemurs of Madagascar*, Pocket Identification Guide; *Nocturnal Lemurs and Lemurs of Madagascar*; and *Diurnal and Cathemeral Lemurs*.

- 2005 Omaha's Henry Doorly Zoo Molecular Genetics Department publishes scientific articles in *American Journal of Primatology*, *Journal of Zoo and Wildlife Medicine* and *Animal Conservation*.
- 2005 Association of Zoological Horticulture Conservation Award for the Bermuda Fern Project.
- 2004 Grant awarded by the State of Nebraska Department of Roads for Phase II of soil microbes and orchid reintroduction research in Nebraska Sandhills.
- 2004 Omaha's Henry Doorly Zoo Molecular Genetics Department publishes "Characterization of Twenty-Two Microsatellite Loci Developed from the Genome of the Woolly Lemur (Avahi laniger)" in *Molecular Ecology Notes* and "Specific Status of Propithecus spp" in *International Journal of Primatology*.
- 2003 First test tube gorilla gives birth to a female gorilla.
- 2002 Recognizing the year for appreciation for involvement and recovery of the black-footed ferret SSP Program.
- 2002 Dr. Edward Louis of Omaha's Henry Doorly Zoo Molecular Genetics Department publishes "Medical Evaluation of Free-Ranging Primates in Betampona Reserve, Madagascar" in *Lemur News*; "Characterization of Seven Microsatellite Marker Loci in a Genus of Malagasy Lemurs (Propithecus)"; and "Characterization of 14 Microsatellite Marker Loci in the Grey Bamboo Lemur (Hapalemur griseus)" in *Molecular Ecology Notes*.
- Grant from Morris Animal Foundation for project entitled "Assisted Reproduction Using Sex-Sorted Sperm: A Management Strategy for Captive Gorillas 2001–2006."
- AZA Significant Achievement Award to Omaha's Henry Doorly Zoo for Betampona Ruffed Lemur Release and Conservation Program, September 2001.
- Received a grant from the State of Nebraska Department of Roads for a program to propagate and reintroduce the Western Prairie Fringed Orchid in 2001.
- Received a grant for a collaborative project with the St. Louis Zoo titled "Prosimian Biomedical Survey, Madagascar" in 2001 to study the biomedical profiles and disease incidence of wild lemur populations in Madagascar.

- 2001 Omaha's Henry Doorly Zoo Molecular Genetics Department publishes "Characterization of Polymorphic Microsatellite Loci from the Two Endemic Genera of Madagascan Boids, Acrantophis and Sanzinia" and "Characterization of Seven Microsatellite Marker Loci in the Malagasy Civet (Fossa fossana)" in *Molecular Ecology Notes*.
- 2001–present Reproductive physiologist Dr. Naida Loskutoff becomes chair of the International Embryo Transfer Society's Parent Committee on Companion Animals, Non-Domestic and Endangered Species (CANDES), the only international scientific forum on reproductive technology in these species.
- 2001–present Reproductive physiologist Dr. Naida Loskutoff develops a novel procedure for removing infectious pathogens from semen from humans, livestock and nondomestic species receiving two U.S., Australian, New Zealand and Canadian patents and is currently being developed for marketing to humans.
- Established the South African Centre for Conservation and Research, initially based at the Johannesburg Zoo, Gauteng, South Africa, 2000–present.
- Received a grant from the Association of Zoological Horticulture to support the Henry Doorly Zoo's program of cryopreservation and storage of plant germplasm in 1999.
- Received a grant from the Morris Animal Foundation titled "Application of Genetic Engineering to Endangered Felid Conservation" in 1999 to develop laboratory cell lines to produce endangered cat reproductive hormones for use in assisted reproduction programs for conservation of these species.
- Received a grant from National Geographic to study genetic diversity of lemurs in protected and fragmented forests in Madagascar in 1999. Work continues on this project today.
- 1998 International Association of Zoological Horticulture Conservation Award for work with plants, habitats, wetlands and prairie conservation.
- 1997 Conservation Award from American Zoo and Aquarium Association for Wyoming toad captive propagation program
- Assisted in producing the world's first test-tube gorilla birth, October 1995.

- 1994 AAZPA Bean Award (most prestigious conservation award) in 1994 for long-term tiger propagation efforts and in 1989 for long-term gaur propagation efforts.
- World's first test-tube gaur born, August 1993.
- 1993 AAZPA Conservation Award for black-footed ferret management.
- World's first artificially inseminated Siberian tiger born in November 1991, and world's first test tube tiger born in April 1990.
- 1989–96 Demoiselle cranes reproduction through artificial insemination.
- 1988, 1990 and 1993 Sandhill cranes born through artificial insemination.

MOVING TO THE FUTURE

Over Memorial Day weekend 2016, a record of more than sixty thousand visitors packed Omaha's Henry Doorly Zoo and Aquarium to celebrate the opening of the $73 million African Grasslands Exhibit—the largest and most expensive in the zoo's history. They backed up traffic on the interstate just trying to get into the zoo and marveled at seeing giraffes, rhinos, antelope, impalas and elephants sharing common open spaces.

Guests were thrilled to witness the future of their zoo coming to life with the opening of this first major exhibit created under the zoo's ten-year master plan. The entire front gate area, aquarium renovations, Omaha Steaks Grill, Infield at the Zoo and all associated guest paths also were part of the master plan. Zoo goers knew that the plan called for additional spectacular "continent" exhibits to come—exhibits that not only showcased animals but also grouped them together in natural settings re-creating their native habitats. It was as if the savannas of Africa had been transported to Omaha, complete with watering holes that must have reminded some guests of the old Disney nature movies.

Omaha's Henry Doorly Zoo and Aquarium was well on its way to developing the future that it envisioned when it created the master plan in 2010.

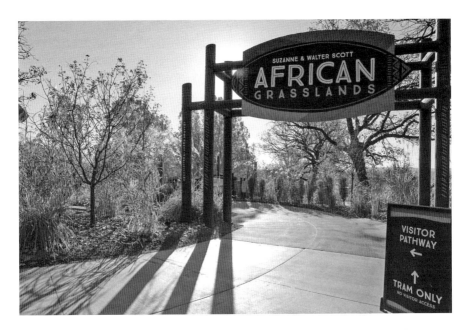

The entrance to the African Grasslands Exhibit, which opened in 2016. *Photo by Mary Plambeck Cook.*

THE MASTER PLAN

Infrastructure Projects

The master plan envisions spending $185 million to expand and update the zoo by early next decade. As of the writing of this book, it is well over halfway to completion. Implementation of the plan began with significant, if less showy, infrastructure improvements like expanded parking and additional eating areas needed to accommodate additional guests. Other projects completed under phase one of the master plan included a new entry, the major renovation of the Suzanne and Walter Scott Aquarium and the building of an education and conference center at the aquarium.[167] All have been aimed at improving the guest experience.

"People like a place that feels welcoming," said Dennis Pate. "We changed the old roads [some of which went back to Riverview Park days] into wider paths. We paved a service road around the zoo so that we can minimize the number of service vehicles on guest paths. When we do have to drive, we've

A new north entrance helps the zoo accommodate its growing attendance. *Photo by Mary Plambeck Cook.*

downsized from pickups to golf carts. There's no danger to kids. All these mundane things add up."[168]

Instead of garbage trucks, zoo workers use golf carts to pick up bags of trash and haul them to a central area for disposal. There also are new restrooms that include baby changing stations. Walking paths are less steep than they used to be to comply with Americans with Disabilities Act regulations and make pushing strollers easier. The new Children's Adventure Trails exhibit will include a baby care station where nursing mothers can feed and change their babies.

But the exhibits of animals grouped by continent in settings mirroring their natural habitats will likely be the master plan's major lasting effect on Omaha's Henry Doorly Zoo and Aquarium.

THE AFRICAN GRASSLANDS

Like the exhibits to come, the African Grasslands offers guests a new way of experiencing the zoo. They stroll along pathways through the twenty-eight-acre exhibit trying to identify the animals that the signs spotlight. At the giraffe-feeding station, they can get an eye-level view of these animals while feeding them. In most places, guests have to be on the lookout to spot

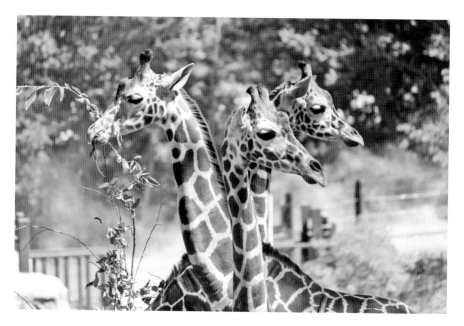

Giraffes in natural settings are popular with visitors to the African Grasslands. *Courtesy of Andrea Hennings.*

Omahans eagerly awaited the arrival of elephants for the African Grasslands exhibit. *Photo by Mary Plambeck Cook.*

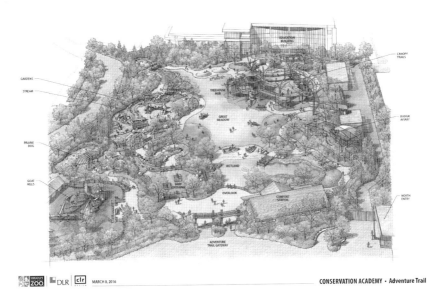

This architect's sketch shows plans for the Children's Adventure Trails. *Courtesy of Dennis Pate.*

the white rhinos, impalas and other animals roaming the grounds behind the fences. Guests might spot a shy cheetah hiding in one of the trees in their enclosure. After hiking up a hill to the African Lodge at the center of the exhibit, guests might also see several lions sunning themselves on massive boulders that can be heated in the winter, but there are no guarantees that the lions will be there—just as there aren't on an African safari.

Then there are the elephants. Omaha's Henry Doorly Zoo and Aquarium rescued six elephants from Swaziland, Africa, for the African Grasslands and built large complex environments for them both indoors and out. The zoo had discontinued displaying elephants for several years due to insufficient numbers to make up a herd, but the public had missed them. There was such excitement when the elephants came to the zoo about a month before the African Grasslands exhibit opened that Dennis Pate said he felt "it was more like a parade than a drive from the airport to the zoo."[169] A bowling alley posted a sign saying, "Welcome to Omaha Elephants."

The *Omaha World-Herald* reported that during the first weekend that the elephants were on display, twenty-three thousand people visited the zoo, several thousand more than on a typical weekend.[170] Pate said that a number of zoos have African exhibits, but Omaha's is rare because it displays elephants with other animals.

A big challenge of opening the African Grasslands exhibit was allowing the various species to acclimate to their homes in the new holding buildings, teaching them to walk through chutes to the display areas and helping the animals get comfortable in those areas and with the other species on display. "The zoo gives animals time to trust the space using positive reinforcement," Pate said. "Some animals, like antelopes, might otherwise run into a fence or a barrier when they feel threatened because their natural defense is to run if they were not given sufficient time to acclimate to their new enclosures."[171]

The African Grasslands is a prototype of other major habitat exhibits that will be built by about 2020. Meanwhile, the year 2016 also marked the opening of the Alaskan Adventure and beginning of construction of Children's Adventure Trails, which is not only an exhibit but also a major expansion of the zoo's educational programming.

Alaskan Adventure

The Alaskan Adventure is a $14 million display that combines the features of a water park with animal sculptures that transport children to coastal waters. Eventually, the adjacent areas will include a new sea lion pool and a home for polar bears.[172] Children love running through the Alaskan Adventure's two-hundred-plus fountains, misters and spray nozzles on hot summer days, but the attraction's major goal is to combine fun with learning about the wildlife of Alaska.

"There are lots of ways to make animals part of our culture including sculptures," Pate said.[173] The Alaskan Adventure contains more than seventy-five life-size bronze sculptures, including its centerpiece: an eighteen-foot-high humpback whale. The whale's tail is a separate sculpture that is sixteen feet wide and eight feet tall, with water flowing from the edge, as it appears to submerge for a deep dive. Other sculptures include thirty jumping salmon, twenty-five puffins, fifteen sea lions sunning on rocks, three porpoising orcas and three brown bears. Water jets off the sculptures in arcs that mimic how the animals would move through the sea in the wild.[174]

Pate said the zoo is trying to make learning about animals fun and to expose the Alaskan animals to "kids that will never see a humpback whale or a brown bear."

Exhibits like the Alaskan Adventure help make it "an outdoor school. We're the biggest school in Nebraska."[175]

ZOO EDUCATIONAL PROGRAMS

Children's Adventure Trails

The zoo has long been heavily involved in a wide array of educational programs ranging from the research opportunities it provides to graduate students at the Center for Conservation Research to the popular Little Lions Preschool. There's an all-day on-grounds zoo kindergarten, and since 2009, the Zoo Academy has offered a daylong high school program for juniors and seniors. Students can complete required science, math, social studies and English classes at the zoo, as well as study animals and explore career opportunities.[176]

To further expand its educational activities, the $27.5 million Children's Adventure Trails exhibit that will open in 2017 focuses on educating children about nature by letting them play in nature. Its components include a children's play area, an amphitheater for bird shows and more classrooms for the zoo's education programs. The added classrooms will allow Zoo Academy high school enrollment to grow by nearly one-third.[177] The outdoor exhibits include a treehouse, elevated paths, a large meadow for animal interactions and a skiff crossing, as well as interactive exhibits for goats, prairie dogs and parakeets.

The new exhibit, which was under construction as this book was being written, is located on five acres north of the Desert Dome and centers on Children's Adventure Trails. Pate said that in designing the exhibit, the zoo first studied the role of play in child development. "We brought in a child development specialist to talk about play and all of the components of play. We looked at the cognitive, physical, social and emotional development that play facilitates."[178]

This is especially important with today's children, who mainly come from small families. "In the big families of old, play was a natural part of growing up," Pate said. Now however, play "is more planned with play dates. One of our goals was to bring back a sense of freedom."[179]

Today's parents tend to monitor and manage play because they are worried about safety. The Children's Adventure Trails will relieve them of that worry by enclosing the space so that children can wander freely. "They'll have the freedom to run around."[180] At "parallel play" areas, kids will be able to explore next to animals at the zoo. In a three-story treehouse, kids can climb and slide next to a primate display at the same elevation. On a low boardwalk, kids will be able to test their balance and agility against a

Children's Adventure Trails exhibit under construction. *Photo by Mary Plambeck Cook.*

herd of goats on a raised platform. They can crawl through tunnels to view a prairie dog habitat through acrylic "bubbles." They can splash around in a shallow stream or walk behind a running waterfall.[181]

Pate said the exhibit is designed to encourage creativity and problem solving in addition to providing children with encounters with animals. Trails will meander and have "tangled pathways" so children don't know "what's around the next corner."[182] At a skiff crossing on the pond, children will have to figure out how to work together to use a small boat to pull themselves across. An open meadow will offer a place for kids to meet animals they can safely handle, such as pythons, chickens, ferrets and box turtles.

Pate compared the new exhibit's freedom to explore in safety to that which families find at the Children's Museum. The new exhibit is designed for children aged four to twelve but includes family-friendly features for smaller children such as a baby care station where nursing mothers can not only change diapers but also nurse.

The Future

The next major exhibit to be built under the master plan is the Asian Highlands exhibit focusing on animals that live in the foothills of the Himalayas and other forested areas in the Far East, such as Siberian tigers, Amur leopards, red pandas, sloth bears and deer. Pate said animals that will be showcased in this exhibit are all adapted to colder weather and thus suitable for display during a Nebraska winter. Eventually, the zoo will build a South American exhibit—but not until it has replaced the Cat Complex and built a new sea lion pool. There will also be an Equatorial African exhibit featuring Central African forest dwellers such as okapi and red river hogs.[183]

One species that the Omaha's Henry Doorly Zoo and Aquarium has ceased pursuing is Chinese giant pandas. Beginning in 1987, it explored the possibility with the Chinese and even designed a display area. Despite the fact that the zoo signed a 2004 nonbinding letter of intent to import the pandas, complications kept arising. Finally, negotiations broke down when the zoo refused a Chinese request to help block a Nebraska trade deal with Taiwan. Since then, the zoo has made no further efforts to acquire pandas.

Pate said he believes this was a good decision because the resources the zoo would have to have committed to pandas might have short-changed the master plan. "I would argue that the money we spent to move forward with the master plan is much better spent in renewing the zoo. We wouldn't have been able to do a lot of this if we focused all of our attention on giant pandas."[184]

In 2016, zoo attendance exceeded two million for the first time, and officials and guests could see the master plan coming to life. The future looked very bright. "More building has been going on here than on any zoo in the country," said Pate. "It requires a very generous community and significant planning on the part of zoo staff, architects and engineers. It's an awesome responsibility and a lot of fun."[185]

Epilogue

It is hard to imagine an institution that has been as true to the inspired vision of its founder as Omaha's Henry Doorly Zoo and Aquarium.

When Mrs. Doorly donated $750,000 to the Omaha Zoological Society and asked that the animals be kept in natural settings instead of cages, many zoos met only the very basic requirements for animal care. Mostly, animals lived in small cages with concrete floors. The Omaha zoo's late start has actually been an advantage because it was spared correcting the mistakes of the past and was free to move imaginatively to the future.

How thrilled Mrs. Doorly would be to see the elephants at the watering holes in the African Grasslands, the birds flying freely in the Simmons Aviary or the butterflies fluttering around the Grewcock Pavilion. This would be her kind of zoo—only far greater than anything she could have imagined.

Mrs. Doorly would also be astonished that the modest zoo she hoped would become a civic asset to Omaha is widely recognized as one of the world's best, as evidenced by the list of awards in Appendix B. Indeed, Omaha's Henry Doorly Zoo and Aquarium has become one of Omaha's signature institutions, and the Desert Dome is an iconic image of today's vibrant Omaha.

A Personal Note

Like nearly all Omahans, I am enormously proud of our zoo. I am one of its more than 86,000 individual and family members (about 300,000 people) and spent countless hours hiking up and down its hills when I was raising my family. Writing this book has made me appreciate Mrs. Doorly's vision of what a great zoo could do for our city more than ever.

I hope this book enhances appreciation of what guests see and experience when they come to the zoo. The zoo contributes so much to Omaha as its major tourist attraction. It has a significant economic impact and is a force for education in the broadest sense. Its international prestige is a significant bragging point for Omaha—something that helps set Omaha apart from other medium-sized midwestern cities. When large numbers of visitors come for the College World Series, the Berkshire Hathaway annual meeting or the Olympic Swim Trials, many stop at the zoo and come away extremely impressed.

I especially hope this book helps readers appreciate the zoo's contributions to animal conservation and research in addition to enjoying its exhibits. I also hope that we carry with us from the zoo not just stuffed

penguins from the gift shop but a greater dedication to preserving animals and their habitats. The zoo, I've learned, isn't just a great place to take the kids for an outing. It offers endless opportunities to expose them to the wonders of nature and the animal kingdom.

How Mrs. Doorly would love this!

HISTORY

2016

» African Grasslands, the largest project in zoo history, opens in its entirety. It is over twenty-eight acres in size and features animals such as elephants, giraffes, lions, white rhinos, cheetahs, impalas, zebras, meerkats, klipspringers, hyraxes and bongos (antelope) and a children's African pygmy goat petting area.

» Alaskan Adventure, located near Red Barn Park and Sue's Carousel, opens to the public. This seasonal exhibit is both a splash ground and water feature that is Alaskan-themed, featuring dancing waters through sprays and spouts and seventy-eight bronze life-size sculptures created by Nebraska's own Matthew Placzek.

» Reconstructed North Gate Entrance opens to the public.

» The STEM Funders Network announces that Omaha's Henry Doorly Zoo and Aquarium and the University of Nebraska and in collaboration—with more than thirty other Omaha organizations—have been selected as one of the ten STEM Learning Ecosystems to join the STEM Learning Ecosystems Initiative, a national initiative, initially developed in 2015–16 beginning with twenty-seven STEM Learning Ecosystems communities across the United States.

» The zoo sets a new milestone for attendance: over two million people visited the zoo in 2016.

2015

» Portions of African Grasslands are completed and open to the public: African Lodge, an indoor concession stand and rental facility; Giraffe Herd Rooms; a train station; and a ticket kiosk.
» The zoo receives the Association of Zoos and Aquarium's Quarter Century Award, which recognizes over twenty-five years of continuous accreditation.

2014

» Stingray Beach is opened to the public. The seasonal interactive exhibit, located by Sue's Carousel, provides zoo visitors the opportunity to touch and feed cownose, Atlantic and southern stingrays.

2013

» Dinosaurs Alive! The Lost Valley is opened to the public. The temporary interactive exhibit featured fifteen life-size animatronic dinosaurs, two of which would be controlled by zoo visitors. The exhibit, located by Owen Sea Lion Pavilion, was open Memorial Day through fall of 2013.
» A video board is installed above the Redemption Gate at the Main Entrance. The digital means of communication is used to promote exhibits, rides, IMAX, events, welcome groups and other zoo news using static images and videos.
» Durham TreeTops Restaurant is renovated. The restaurant now features digital menu boards, as well as new signage and seating to carry out the jungle theme.
» Rosenblatt's Infield at the Zoo—a commemoration to Rosenblatt Stadium—is completed. A new parking lot containing one thousand new parking spaces was added in what was the outfield of Rosenblatt Stadium.
» Rosenblatt Stadium's media tower is installed at Wildlife Safari Park. It is now called Crane Meadows Viewing Tower.
» A new main gift shop is completed.

2012

» The newly renovated Suzanne and Walter Scott Aquarium opens on April 5, 2012.
» The new main entrance opens with new ticketing gates, restrooms, first aid, guest services and redemption gates.
» The updated Red Barn Park area is completed with the new Prehistoric Play Park and Fossil Dig site.

2011

» The Omaha Steaks Grill and Patio, located between the Durham TreeTops Restaurant and the Lied Jungle, opens.
» The Durham Lodge and Birthday House renovations are completed.

2010

» Expedition Madagascar opens to the public. Expedition Madagascar showcases the conservation work Omaha's Henry Doorly Zoo and Aquarium dedicates to Madagascar.

2009

» Skyfari, an aerial tram, opens to the public.
» The Omaha Zoological Society Board names Dennis Pate as executive director of Omaha's Henry Doorly Zoo and Aquarium.

2008

» Berniece Grewcock Butterfly and Insect Pavilion opens. Construction on Skyfari and Expedition Madagascar begins.

2007

» Mutual of Omaha's Wild Kingdom Pavilion is transformed into the Exploration Station.

2006

» A new guest services building and two additional gates at the main entrance open.
» The Hubbard Research wing expansion to the Grewcock Center for Conservation and Research opens.
» Budgie Encounter, a walk-through exhibit, opens.

2005

» Hubbard Orangutan Forest, the best view in the zoo, opens in two phases in May and August.
» A giraffe-feeding station opens in the spring.

2004

» Hubbard Gorilla Valley, where gorillas roam free, opens.
» A tower with two high-capacity elevators to take visitors from the main level of the zoo near the Desert Dome down forty-four feet to Hubbard Gorilla Valley opens.

2003

» Eugene T. Mahoney Kingdoms of the Night®, the world's largest nocturnal exhibit, opens beneath the Desert Dome. It features caverns, bat caves and the world's largest indoor swamp.

2002

» The Desert Dome, the world's largest indoor desert, opens to over 1.5 million visitors. This facility exhibits three different deserts of the world—the Namib, the Central Australian and the Sonoran—under a glazed geodesic dome that is the largest of its kind.

2001

» Cheetah Valley opens.
» New bongo and tree kangaroo exhibits are constructed.
» The zoo hosts a traveling white alligator exhibit.

2000

» The new North Entrance Plaza is completed and features a new gift shop, a warehouse, an entrance plaza and a visitor gazebo.
» Joining the Okapi Species Survival Program allows the zoo to be one of only eighteen zoos in North America to display rare okapi.
» A traveling koala exhibit visits the zoo.

1999

» Sue's Carousel, a thirty-six-foot carousel featuring thirty wild animals and horses, opens near Dairy World.
» The zoo hosts a temporary Komodo dragon exhibit.

1998

» Garden of the Senses, a therapeutic formal garden area where guests can see, hear, touch and smell plants and surrounding elements, opens.
» The Lee G. Simmons Conservation Park and Wildlife Safari, twenty-two miles west of Omaha's Zoo at Nebraska's 1-80 Exit 426, opens.
» A new diet kitchen is completed.

1997

» Lozier IMAX® 3D Theater opens.

1996

» The Bill and Berniece Grewcock Center for Conservation and Research (CCR) opens.
» Timu, the world's first test tube gorilla, moves to Omaha.

1995

» The Walter and Suzanne Scott Kingdoms of the Seas Aquarium opens, and the zoo hosts more than 1.6 million visitors.
» Land is acquired for an off-site breeding facility and drive-through park.
» The zoo participates in the propagation of the world's first test tube gorilla birth. (Timu was born at the Cincinnati Zoo.)

1994

» The Union Pacific Engine House for the Omaha Zoo Railroad is completed.

1993

» The old aquarium is closed, and construction of the new aquarium begins.
» The zoo receives two AAZPA awards: the Conservation Award for its black-footed ferret management program and the Significant Achievement Award for the Lied Jungle.
» The world's first artificially inseminated gaur calf is born at the zoo.

1992

» The Lied Jungle®—the world's largest indoor rainforest at that time—and the Durham TreeTops Restaurant and Education Center open.
» Simmons Plaza, near the main entrance, is completed.

1991

» The Birthday House, a building for children's birthday parties and education classes, opens.
» The world's first artificially inseminated tiger is born at the zoo.

1990

» Dairy World, featuring the children's petting zoo, educational exhibits and concession area, opens.
» The world's first test tube tiger is born at the zoo.

1989

» Durham Family's Bear Canyon is dedicated.
» *Doorly's Pride*, a heroic bronze sculpture of a pride of twelve lions, is installed in the entry plaza area.
» The zoo receives the prestigious AAZPA Bean Award for its long-term gaur propagation efforts.
» The black-footed ferret building is constructed.

1988

» Construction begins on the $15 million Lied Jungle®.
» The zoo is selected as one of three sites for the endangered black-footed ferret breeding program.
» The zoo's greenhouse is built near the maintenance shop.

1987

» Mutual of Omaha's Wild Kingdom Pavilion, a hands-on educational building, is completed, and US West Plaza, a visitor services area, opens.
» A new main entrance at the south end of the parking lot opens.

1986

» World-Herald Square is completed, and First Tier Wolf Woods opens.
» The maintenance building and hay barn are relocated to the northeast area of the zoo.

1985

» The gorilla and orangutan buildings are completely renovated and named in honor of the Owen family.

1984

» A seventy-thousand-gallon saltwater aquarium opens in what had been the museum.

1983

» The zoo receives national accreditation from the Association of Zoos and Aquariums, honoring its commitment to maintaining the highest standards in animal care and welfare and inspiring guest engagement through effective education and conservation.
» The world's second-largest walk-through aviary, Lee G. Simmons Free-Flight Aviary, opens.

1981

» The giraffe and hoofstock complex opens.

1979

» The hospital and nursery open.

1977

» The largest cat complex in North America opens.

1974

» The new diet kitchen and educational classrooms are completed.

1973

» Owen Swan Valley and the Primate Research Building are completed.

1972

» The Aksarben waterfall is constructed. In August, the 1916 public swimming pool that had been buried in 1944 and rediscovered in 1970 is reconstructed and becomes the Owen Sea Lion Pavilion, complete with a new concessions building, public restrooms and a gazebo.

1970

» Dr. Lee G. Simmons is named executive director of Henry Doorly Zoo (1970–2009).
» Dr. Warren Thomas ends his role as zoo director.

1968

» With help from Union Pacific, two and a half miles of track are laid through the zoo. Omaha's Zoo Railroad makes its inaugural run in

July. Eppley Pachyderm Hill opens in November on the old baseball diamond site.

1965

» The Omaha Zoological Society is reorganized to plan, construct, operate and maintain the zoo for the city as a nonprofit organization. The first phase of the zoo is dedicated to Henry Doorly. The bear grottos, gorilla and orangutan buildings and Aksarben Nature Kingdom are part of this phase.

1964

» Dr. Warren Thomas is appointed zoo director (1964–1970).

1963

» Margaret Hitchcock Doorly donates $750,000 to the zoo, with the stipulation that the zoo be named after her late husband, Henry Doorly, chairman of the World Publishing Company.

1953

» Floyd Hinton is appointed zoo director (1953–63).

1900–1952

» New exhibits and other improvements are made to support the growing number of animals in the park. In 1952, the Omaha Zoological Society organizes to improve the zoo and provide administrative help to the city.

1930s

» New cat and bear exhibits are built by the Works Progress Administration.

1920s

» New cat cages are donated by Gould Dietz.

1898

» The park has an animal population that includes deer, a grizzly bear, 2 bison on loan from Colonel William F. Cody and 120 other animals.

1897

» Nels Anderson is named caretaker of animals of Riverview Park (1897–1912).

1894

» Riverview Park is founded by the City of Omaha.

ZOO AWARDS

» 2016 Salt Creek Tiger Beetle Conservation Award, presented by Association of Zoos and Aquariums

» 2016 Friend of the Environment Award, Business/Organization Winner, presented by Earth Day Omaha

» 2015 Best Tourist Attraction by Readers' Choice Best of the Big O

» 2015 Best Wedding Venue by Readers' Choice

» 2015 Top Zoo in Nebraska, *Go Wild! The Best Zoo in Every State*, Yahoo! Travel online, June 2015

» 2015 Ranked No. 1 Zoo by *Family Fun* magazine

» 2015 TripAdvisor Certificate of Excellence Award

» 2015 TripAdvisor Certificate of Excellence Award; Wildlife Safari Park

» 2015 Nebraska Future Business Leaders of America (FBLA) 2015 Business of the Year

» 2015 No. 2 Zoo in the United States and No. 6 Zoo in the World by TripAdvisor

» 2015 Listed on "10 Best Things to Do in Omaha" on VacationIdea.com

» Nebraska's No. 1 attended Tourist Attraction

» 2014 Top Zoo in the World by TripAdvisor

» 2014 Ranked No. 9 Aquarium in North America by 10Best Readers' Choice—Omaha's Henry Doorly Zoo and Aquarium is the only zoo and aquarium on the top 10 list; all others are standalone aquariums

» 2014 Ranked No. 1 Zoo by *Family Fun* magazine

» 2014 Ranked No. 6 Zoo on Best US Zoo by 10Best Readers' Choice

» 2014 Largest Zoo in the World, Touropia

» 2014 Ranked Top US Zoo by *FamilyFun* magazine

» 2014 Ranked No. 7 for Favorite Family Destination in the US by *Family Fun* magazine

» 2013 Chairman of the Omaha Zoo Foundation, Dr. Lee Simmons, named the 2013 recipient of the Conservation Breeding Specialist Group (CBSG) Ulysses S. Seal Award

» 2013 Ranked Top Zoo by *Family Fun* magazine

» 2012 Ranked No. 1 Zoo in the country by TripAdvisor

» 2012 Largest Zoo in the World by Touropia.com

» 2010, 2011, 2012 and 2013 Voted Best of Omaha Family Entertainment Venue

» *America's Best Zoos* by Allen W. Nyhuis and Jon Wassner listed Omaha's Zoo as one of the 10 best zoos in the United States.

» 2011 Nebraska Academy of Science Friend of Science

» 2011 SeaWorld Busch Gardens Environmental Excellence Award

» 2011 Nebraska Education Association Friend of Education

» 2011 Omaha Public Schools Award

» 2010 Association of Zoos and Aquariums Conservation Award for the Madagascar Biodiversity Program. The award recognizes exceptional efforts toward regional habitat preservation, species restoration and support of biodiversity in the wild.

» 2010 and 2006 Nebraska Association of Teachers of Science Catalyst Award

» 2009 Omaha's Zoo was awarded the Nickelodeons Parents Pick for Best Day Camp

» 2008 Omaha's Zoo was awarded the Nickelodeons Parents Pick for Best Day Camp

» 2007 Omaha's Zoo featured in the book *1,000 Places in the United States and Canada to See Before You Die*, written by Patricia Schultz

» 2006 Promising Partnership Practice Award winner

» 2006 Youth Volunteer Corps Award and the 2006 Court Referral Community Service Program Award

» 2005 Zoo director Dr. Lee G. Simmons inducted into Knights of Aksarben Court of Honor and the 2005 Recipient of the Power-Is-In-The-Partnership Award from Nebraska Diplomats Incorporated because of his support and contributions to Nebraska's business climate

» 2005 Recipient of Phi Delta Kappa Outstanding Service to Education Award for exceptional educational leadership and recipient of NCE Conference Outstanding Business Partnership Award for significant contributions to the success of career education

» Zoo director Dr. Lee G. Simmons honored with the 2005 Outstanding Business Industry Partnership Award

» Omaha's Zoo named Best Zoo by *Reader's Digest*, May 2004

» 2004 Zoo director Dr. Lee G. Simmons inducted into the Omaha Chamber of Commerce Hall of Fame, first nonprofit to receive this award

» 2003 Zoo director Dr. Lee G. Simmons received Henry Fonda Award from the Nebraska Department of Tourism for lifelong achievements in promoting tourism in the state

» Omaha's Zoo earned the 2003 Harding Award of Excellence for its efficient and innovative energy conservation from Omaha Public Power District and honored as the 2003 Outstanding Explorers Post award

» Rising Star Award to Omaha's Henry Doorly Zoo Desert Dome in recognition and appreciation of significant efforts to "Make the Good Life Better" and for promoting tourism in Nebraska by the NebraskaLand Foundation Incorporated on June 6, 2003

» 2001 Engineering Excellence Grand Award for Central Cooling Plant

» Disney-owned *Family Fun Magazine* ranked Omaha's Zoo as America's No. 1 Family Friendly attraction, June–July 1999

» *Family Life Magazine* selected Omaha's Zoo as one of the top zoos in the country, September–October 1998 and July–August 1994

» 1997 and 1995 recipient of the Vital Link Award

» 1995 Nebraska Vision Award

» National Geographic photographer Mike Nichols featured Omaha's Zoo in his book *Keepers of the Kingdom: The New American Zoo*

» *Good Housekeeping Magazine* named Omaha's Zoo one of the top ten zoos in the country, June 1994

» *Family Life Magazine* named the Lied Jungle® the single best zoo exhibit in the country, July–August 1994

» 1993 AAZPA (American Association of Zoological Parks and Aquariums) Significant Achievement Award for Exhibit Design for the Lied Jungle

» *Time* magazine named the Lied Jungle® as one of the top ten designs in the world for 1992

» The Lied Jungle® was selected as one of the top eight U.S. engineering accomplishments in 1992 by the National Society of Professional Engineers

NOTES

Introduction

1. Dennis Pate, interview with author, September 20, 2016.
2. Dr. Lee G. Simmons, interview with author, August 24, 2016.
3. Ibid., July 12, 2016.
4. Margaret Doorly, letter to Omaha Zoological Society, August 26, 1963.
5. Pate, interview, August 9, 2016; Dr. Eric Thompson, *DRAFT Final Report: Economic and Fiscal Impact of Omaha's Henry Doorly Zoo and Aquarium on Omaha and Nebraska. The 2015 Update* (Lincoln: University of Nebraska–Lincoln Bureau of Business Research Department, 2016), 2–3.

Chapter 1

6. Lawrence H. Larsen et al., *Upstream Metropolis*, 130–31.
7. "History," Omaha's Henry Doorly Zoo and Aquarium, accessed October 25, 2016, http://www.omahazoo.com/about/history.
8. Larsen et al., *Upstream Metropolis*, 123.
9. Handwritten description of Riverview Park, Douglas County Historical Society.
10. Historical Society of Douglas County, *The Banner Newsletter for the Historical Society of Douglas County* (May–June 2000): 6.
11. Simmons, interview, July 29, 2016.

12. *Omaha's Historic Park and Boulevard System*, 17–18, Nebraska History Collection at Omaha Public Library's W. Dale Clark Library.
13. Ibid.
14. Handwritten description of Riverview Park, Douglas County Historical Society.
15. *Omaha's Historic Park and Boulevard System*, 17–18.
16. *Omaha Parks and Recreation Department Report*, Omaha, 1917, Nebraska History Collection at Omaha Public Library's W. Dale Clark Library.
17. Al Frisbie, "1919 Drownings Mar History of Riverview," *Omaha World-Herald*, August 5, 1962.
18. Hamilton, *Believe It, Omaha*, 19.
19. Simmons, interview, July 12, 2016.
20. Frisbie, "1919 Drownings Mar History of Riverview."
21. Hamilton, *Believe It, Omaha*, 19.
22. Frisbie, "1919 Drownings Mar History of Riverview"; "History."
23. "History."
24. "Give Away the Buffalo," *Omaha World-Herald*, September 26, 1939.
25. "Pointless Steaks that Omaha Missed," *Sunday World-Herald*, May 13, 1945.
26. Bill Billotte, "Twas a Sad Walk for Joe Zoo Sold Down the River," *Omaha World-Herald*, September 5, 1943.
27. Handwritten description of Riverview Park, Douglas County Historical Society.
28. Nebraska Parks and Recreation Commission, *1947–1957 Ten Years of Progress*, Omaha, Nebraska, 1957.
29. "Goal: An Omaha Zoo That's a Real Zoo," *Sunday World-Herald*, April 19, 1953.
30. "Expert Declares Omaha Zoo Has Natural Ideal Location," *Omaha World-Herald*, March 10, 1955.
31. "Omaha Gets Zoo Master Plan," *Omaha World-Herald*, September 12, 1955.
32. Simmons, interview, July 12, 2016.
33. "Zoo Planned at Riverview," *Omaha World-Herald*, January 5, 1958.
34. Eldon Coroch, "Children's Zoo Takes Giant Step," *Omaha World-Herald*, January 13, 1963.
35. "Mrs. Doorly Gives $750,000," *Omaha World-Herald*, August 29, 1963.
36. "Ever Since a Small Child Mrs. Doorly Loved Animals," *Omaha World-Herald*, August 29, 1963.
37. Margaret Doorly, letter.
38. Kay D. Clark, letter to Larry Shoemaker, August 24, 1964.

Chapter 2

39. "After Struggling for Years, Doorly Gift Suddenly Brings 'New Day,'" *Omaha World-Herald*, September 1, 1963.
40. Simmons, interview, July 12, 2016.
41. Frisbie, "Good Zoo Terrific Asset to City," *Omaha World-Herald*, December 20, 1963.
42. "Zoo's Director Sees Bright Future," *Omaha World-Herald*, January 10, 1965.
43. "Riverview Zoo Given Big Boost," *Omaha Sun*, June 25, 1964.
44. Simmons, interview, July 12, 2016.
45. "Zoo Plans Embroiled in Confusion," *Omaha Sun*, July 30, 1964.
46. "Expert's Nod to Riverview," *Omaha World-Herald*, July 29, 1964.
47. Woodson Howe, "Zoological Society Is Hoping to Start Doorly Zoo in Fall," *Omaha World-Herald*, May 10, 1964.
48. "Ak Provides $165,000 for Zoo," *Omaha World-Herald*, December 30, 1965.
49. Simmons, interview, July 12, 2016.
50. Ibid.
51. Ibid.
52. Ibid.
53. Ibid.
54. Ibid.
55. Ibid.
56. Mary McGrath, "3 Golden Spikes Open Zoo's Rail," *Omaha World-Herald*, July 23, 1968.
57. "Train," Omaha's Henry Doorly Zoo and Aquarium, accessed July 28, 2016, http://www.omahazoo.com/visit/rides/train.
58. Ibid.
59. "Zoo Acquires Lonely Gorilla, Train; Set Attendance Record," *Omaha World-Herald*, September 8, 1968.

Chapter 3

60. Simmons, interview, July 29, 2016.
61. Ibid.
62. Ibid.
63. Joe Stark, "Zoo's 6 Sea Lions Punctuate Speaker at Pool's Dedication," *Omaha World-Herald*, August 27, 1972.

64. "Other Exhibits: Owen Sea Lion Pavillion," Omaha's Henry Doorly Zoo and Aquarium, accessed July 28, 2016, http://www.omahazoo.com/exhibits/other/owen-sea-lion-pavilion.
65. Simmons, interview, July 29, 2016.
66. Ibid.
67. Ibid.
68. Ibid.
69. Ibid.
70. "Other Exhibits: Cat Complex," Omaha's Henry Doorly Zoo and Aquarium, accessed July 28, 2016, http://www.omahazoo.com/exhibits/other/cat-complex.
71. Simmons, interview, July 29, 2016.
72. Ibid.
73. Tim Norris, "Heater Suspected in Zoo Fire Fatal to Animals," *Omaha World-Herald*, January 14, 1979.

Chapter 4

74. Simmons, interview, August 10, 2016.
75. "Simmons Aviary," Omaha's Henry Doorly Zoo and Aquarium, accessed August 9, 2016, http://www.omahazoo.com/exhibits/aviary.
76. Ibid.
77. Simmons, interview, August 10, 2016.
78. Ibid.
79. "Mutual of Omaha's Wild Kingdom Pavillion," Omaha's Henry Doorly Zoo and Aquarium, accessed August 9, 2016, http://www.omahazoo.com/exhibits/wild-kingdom-pavilion.
80. Simmons, interview, August 10, 2016.
81. "Other Exhibits: Durham's Bear Canyon," Omaha's Henry Doorly Zoo and Aquarium, accessed August 10, 2016, http://www.omahazoo.com/exhibits/other/durhams-bear-canyon.
82. "The Doorly Pride, Lions Pride," Public Art Omaha, accessed August 18, 2016, http://www.publicartomaha.org/art/info/126/The+Doorly+Pride%2C+Lions+Pride.

Chapter 5

83. Simmons, interview, August 24, 2016.

84. Ibid.

85. Ibid.

86. "Lied Jungle®," Omaha's Henry Doorly Zoo and Aquarium, accessed August 24, 2016, http://www.omahazoo.com/exhibits/lied-jungle.

87. Ibid.

88. Ibid.

89. Ibid.

90. Simmons, interview, August 24, 2016.

91. Ibid.

92. Ibid.

93. "Suzanne and Walter Scott Aquarium," Omaha's Henry Doorly Zoo and Aquarium, accessed August 24, 2016, http://www.omahazoo.com/exhibits/aquarium.

94. Ibid.

95. Ibid.

96. Kendrick Blackwood, "Membership Drive Shatters Zoo's Record," *Omaha World-Herald*, April 19, 1995.

97. Simmons, interview, August 24, 2016.

98. Chris Peters, "Omaha Zoo's Safari Park, Little Changed Since 1998 Opening in Line for an Overhaul," June 15, 2016, http://www.omaha.com/living/zoo.

99. Simmons, interview, August 24, 2016.

100. "Other Exhibits: Garden of the Senses," Omaha's Henry Doorly Zoo and Aquarium, accessed August 24, 2016, http://www.omahazoo.com/exhibits/other/garden-of-the-senses.

101. Simmons, interview, August 24, 2016.

Chapter 6

102. Simmons, interview, September 13, 2016.

103. Ibid.

104. Ibid.

105. "Desert Dome," Omaha's Henry Doorly Zoo and Aquarium, accessed September 12, 2016, http://www.omahazoo.com/exhibits/desert-dome.

106. Ibid.; Simmons, interview, September 13, 2016.

107. Simmons, interview, September 13, 2016.

108. Ibid.

109. Ibid.

110. Ibid.

111. "Desert Dome."

112. Simmons, interview, September 13, 2016.

113. Niz Proskocil, "Dome Alone? Crowds Make that Unlikely," *Omaha World-Herald*, April 4, 2002.

114. Niz Proskocil, "Desert Called a Success; What's Next? Nocturnal World More than 1 Million People Have Walked Through the Dome Since March," *Omaha World-Herald*, September 25, 2002.

115. Niz Proskocil, "Desert Dome Heats Up Membership Drive: The New $31.5 Million Exhibit Spurs the Second-Best Drive in Zoo History," *Omaha World-Herald*, May 1, 2002.

116. Niz Proskocil, "New Zoo Attraction Wins 'Wow' Rating on First Day," *Omaha World-Herald*, April 2, 2003.

117. Jane Palmer, "Member Total Hits Zoo's Goal," *Omaha World-Herald*, April 30, 2003.

118. Simmons, interview, September 13, 2016.

119. Ibid.

120. Ibid.

121. "Hubbard Gorilla Valley," Omaha's Henry Doorly Zoo and Aquarium, accessed September 12, 2016, http://www.omahazoo.com/exhibits/gorilla-valley.

122. "Hubbard Orangutan Forest," Omaha's Henry Doorly Zoo and Aquarium, accessed September 12, 2016, http://www.omahazoo.com/exhibits/orangutan-forest.

123. "Berniece Grewock Butterfly and Insect Pavillion," Omaha's Henry Doorly Zoo and Aquarium, accessed September 12, 2016, http://www.omahazoo.com/exhibits/butterfly-insect-pavilion.

124. Simmons, interview, September 13, 2016.

125. Ibid.

Chapter 7

126. Simmons, interview, September 23, 2016.

127. Ibid.

128. David Hendee, "A New King of the Jungle—Simmons Will Take New Role at the Zoo," *Omaha World-Herald*, January 14, 2009.

129. Henry Cordes, "Jacksonville Zoo Chief to Build on Successes," *Omaha World-Herald*, January 15, 2009.

130. Pate, interview, September 20, 2016.

131. Henry Cordes, "A Love of the Wild Kingdom Pate Works to Inspire that Fascination in Others," *Omaha World-Herald*, January 17, 2009.

132. Ibid.

133. Pate, interview, September 20, 2016.

134. Ibid.

135. Ibid.

136. Ibid.

137. Simmons, interview, September 23, 2016.

138. Ibid.

139. "Let's Preserve a Piece of Rosenblatt," *Omaha World-Herald*, June 19, 2009.

140. Dennis Pate quoted in Carol Bicak, "Little 'Oasis Park' at the Zoo," *Omaha World-Herald*, June 10, 2010.

141. Ibid.

142. Editorial, *Omaha World-Herald*, July 2, 2010.

143. "Infield at the Zoo," Omaha's Henry Doorly Zoo and Aquarium, accessed September 19, 2016, http://www.omahazoo.com.

144. Pate, interview, September 20, 2016.

145. Julie Anderson, "New Exhibit Reflects Zoo's Commitment to Conservation," *Omaha World-Herald*, May 1, 2010.

146. Dennis Pate quoted in Anderson, "New Exhibit Reflects Zoo's Commitment to Conservation."

147. Simmons, interview, September 23, 2016.

148. Anderson, "New Exhibit Reflects Zoo's Commitment to Conservation."

149. "Expedition Madagascar," Omaha's Henry Doorly Zoo and Aquarium, accessed September 21, 2016, http://www.omahazoo.com/exhibits/expedition-madagascar.

150. Simmons, interview, September 23, 2016.

Chapter 8

151. Simmons, interview, August 10, 2016.

152. Dr. Douglas Armstrong, interview, September 29, 2016.

153. Ibid.

154. Simmons, interview, August 10, 2016.

155. Simmons, interview, July 29, 2016.

156. Simmons, interview, August 10, 2016.

157. Ibid.

158. Ibid.

159. Armstrong, interview, September 29, 2016.

160. "Rare Plant Research," Omaha's Henry Doorly Zoo and Aquarium, accessed September 28, 2016, http://www.omahazoo.com/conservation/rare-plant-research.

161. "Conservation," Omaha's Henry Doorly Zoo and Aquarium, accessed September 28, 2016, http://www.omahazoo.com/conservation.

162. Armstrong, interview, September 29, 2016.

163. Ibid.

164. Ibid.

165. Ibid.

166. Pate, interview, September 20, 2016.

Chapter 9

167. "Master Plan," Omaha's Henry Doorly Zoo and Aquarium, accessed December 14, 2015, http://www.omahazoo.com/about/master-plan.

168. Pate, interview, September 28, 2016.

169. Ibid.

170. Chris Peters, "Visitors Pack Omaha Zoo to See New Pachyderms," *Omaha World-Herald*, April 12, 2016.

171. Pate, interview, September 28, 2016.

172. "Alaskan Adventure," Omaha's Henry Doorly Zoo and Aquarium, accessed October 7, 2016, http://www.omahazoo.com/exhibits/alaskan-adventure; "Master Plan."

173. Pate, interview, September 28, 2016.

174. "Alaskan Adventure"; "Master Plan."

175. Pate, interview, September 28, 2016.

176. "Education Programs," Omaha's Henry Doorly Zoo and Aquarium, accessed October 6, 2016, http://www.omahazoo.com/education.

177. Blake Ursch, "Kids Will Learn as They Play at Zoo," *Omaha World-Herald*, August 31, 2016.

178. Pate, interview, September 28, 2016.

179. Ibid.

180. Ibid.

181. Ursch, "Kids Will Learn as They Play at Zoo."

182. Pate, interview, September 28, 2016.

183. "Master Plan"; Pate, interview, September 28, 2016.

184. Chris Peters, "Panda Pursuit Is History," *Omaha World-Herald*, October 2, 2016.

185. Pate, interview, September 28, 2016.

BIBLIOGRAPHY

Armstrong, Douglas. Director of Animal Health, Omaha's Henry Doorly Zoo and Aquarium. Interview with the author. September 29, 2016.

Hamilton, Howard. *Believe It, Omaha (or NOT)*. Omaha, NE: self-published, 2003.

Larsen, Lawrence H., Barbara J. Cottrell, Harl A. Dalstrom and Kay Calame Dalstrom. *Upstream Metropolis: An Urban Biography of Omaha and Council Bluffs*. Lincoln: University of Nebraska Press, 2007.

Omaha's Henry Doorly Zoo and Aquarium. omahazoo.com.

Pate, Dennis. Executive Director and CEO, Omaha's Henry Doorly Zoo and Aquarium. Interview with the author. August 9, 2016; September 20, 2016; September 28, 2016.

Simmons, Lee G. Chairman of the Omaha Zoo Foundation Board and former executive director and CEO, Omaha's Henry Doorly Zoo and Aquarium. Interview with the author. July 12, 2016; July 29, 2016; August 10, 2016; August 24, 2016; September 13, 2016; September 23, 2016.

Wakeley, Arthur C. *Omaha: The Gate City and Douglas County, NE*. Chicago: S.J. Clarke Publishing, 1917.

INDEX

Z

ABOUT THE AUTHOR

Eileen Wirth, PhD, is professor emeritus of journalism at Creighton University and a senior writer for Legacy Preservation in Omaha. She is a former reporter at the *Omaha World-Herald* and author of seven books, including *From Society Page to Front Page: Nebraska Women in Journalism*. She is active in many groups, including the board of the Nebraska State Historical Society.

Visit us at
www.historypress.net

..

This title is also available as an e-book